U0152275

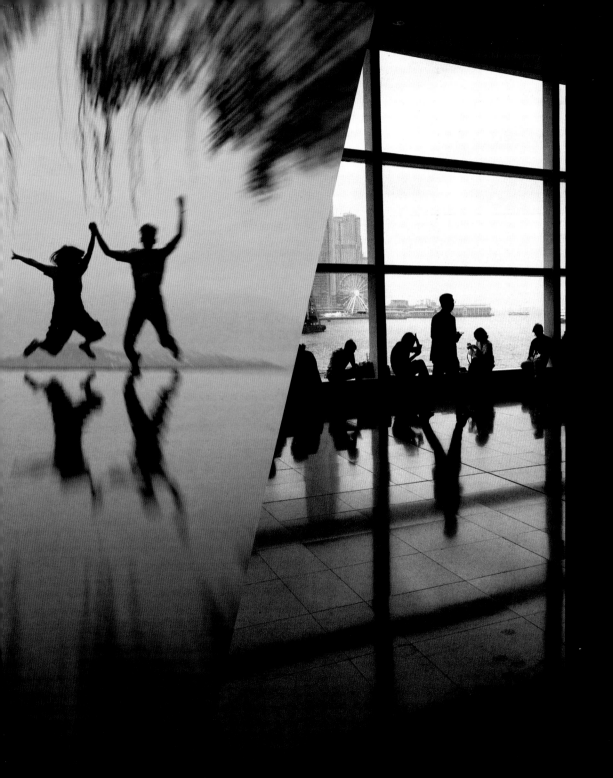

TREASURE ISLAND:
The Adventures of A Dreamer
A Soul Searching Photo Journal by Peter K.C. Ho

追夢者的樂園

攝影／文字（中英雙語）：何廣暢

每一幅攝影作品都
暗藏故事

———李易璇
香港芭蕾舞團行政總監
香港美國商會「最具影響力女性——藝術大師」2021 年得獎者

每一幅攝影作品都暗藏故事

女性其實對女性特別敏感。第一次被 Peter 的照片所觸動,是看到他的作品《半生緣》（A Streetcar Named Desire）。女人是被攝者,她神遊、她思考、她遠望他方⋯⋯她的眼神自主她此時所在,但卻把我帶到了另一個世界,照片和我之間產生了一種共鳴,讓我聯想到了我的故事,一個女人的故事。

每一幅攝影作品,裏面都暗藏了攝影者和被拍攝的人、事、物之間的一些故事。攝影者的眼中看到什麼?聯想到什麼?在按下快門的那一刻,他希望呈現在觀賞者面前的是什麼?然後觀賞者看到照片的那一刻聯想到的,又是什麼?

每個人的背景、經歷、教育和文化不同,我們會以自身的價值觀,代入到我們所觀賞的照片上,觀賞的往往是照片與我們之間的關係,而背後,或許都是為了尋求共鳴,成就我們很獨特、很私密的觀賞。當光影浮動,Peter 手中的鏡頭攝取的那個瞬間、那個風貌的當下,組成了《追夢者的樂園》,你在他浮光掠影的大千世界裏,又能找到多少共鳴以及你自己的故事?

李易璇 Heidi Lee

香港芭蕾舞團行政總監
香港美國商會「最具影響力女性——藝術大師」2021 年得獎者
2021 年 11 月

追夢，從來沒有太遲！

多得社交媒體發展蓬勃，在網絡平台上讀了很多精彩故事，也認識了不少來自東西南北、擁有不同背景的人士，包括何廣暢，一位通過攝影去追夢的作家。

無論是攝影或繪畫，又或是音樂、舞蹈等，都是世界的共通語言。藝術，果然可以把人聯繫起來。今次也因為藝術，我有機會替何廣暢的新書寫序。

記得當年我大學畢業後，不太敢對人說自己是修讀藝術的，因為當時藝術仍然是眾人口中的非主流學科。但多年後的今天，大家對藝術有更深的認識、更多的喜愛、及更願意接受，甚至乎藝術已不是只供觀賞，而是擁有一種無名的治癒能力。

藝術不是只可遠觀，更可近距離融入我們生活當中，觸動我們的情緒感覺，安撫我們的心靈。通過一幅畫、一張相片、一段文字、一件藝術品，城市人在忙碌一天後得到喘息的機會，沉重的思緒得到釋放的空間，思想可以在海闊天空下遊走。莫名的感動就在一瞬間出現，人也不知不覺間得到治癒，變得開懷。

何廣暢的《追夢者的樂園》有大都會繁華商業區的風光，也有寧靜漁村的面貌，云云眾生相，無論是順流或逆流，正如書中配合圖片的勵志金句說明，逝去的歲月不會再回頭，海闊天空，我們更加要活在當下。翻開此書，通過圖片及文字，讓思想跳出框框，豁然開朗 ……

陳智思 Bernard Chan, GBM, GBS, JP.
香港社會服務聯會主席
2021 年 11 月

「追夢」的意義

追夢，有人視為不切實際的行為，但我卻認為它是推動人生奮勇向前的動力。

追夢的路途並不平坦，容易令人洩氣，所以必須具備「孜孜不倦，堅持到底」的信念，而這種信念也正是我尋找人生方向的關鍵。還記得我當初遇上「地理資訊系統」（GIS），便感覺到它有獨特的潛在價值，為了把它發揚光大，我毅然辭去高薪厚職，創立公司獨力推廣。期間經歷了不少挫敗，但我一直堅守著信念，從未想過放棄。至今，不少行業都認同 GIS 的價值，並陸續採用，令我心存感恩，證明信念和堅持可以創造成果。

事實上，追夢從沒有地域和時間的界限，更沒有年齡的限制，任何人只要勇於追尋，都能夠成就燦爛的人生。好像《追夢者的樂園》的攝影作者何廣暢先生，他在財經界馳騁多年，早已名成利就，仍不斷追尋夢想，可謂追夢者的典範。他的追夢作品——《追夢者的樂園》探索多處地方的夢幻場景，分別在香港、美國、加拿大、日本等地捕捉不同的影像，奇妙地把當地的人和地串連起來，再配上由衷的勵志金句，足以感動每位讀者的心靈，同時引領大眾感受人生的真諦。

何先生的追夢人生也令我想起我已故的三叔和四叔。叔叔們一生勤奮於事業，工餘時熱愛透過鏡頭記錄香港動人的景緻和旅遊見聞。就算踏垂暮之年，各自成家並分別定居於香港和加拿大兩地，二人仍對攝影滿腔熱忱，心中同時渴望在香港實現舉辦攝影展的夢，目的是想把歷年來拍下的相片和故事公諸同好，讓更多人可以欣賞他們的攝影作品。最後，他們於香港藝術中心成功舉辦了一個小型攝影展，在有生之年把夢想實現。

誠然，追夢總會令人疲倦不堪。大家都一直為夢想而努力，可是我們追夢的熱情卻從不會因為歲月的流逝而減退。

我有幸為何先生的《追夢者的樂園》執筆寫序，讓我有機會再次思考「追夢」的意義。在此希望每位追夢者都能夢想成真，謹記只要努力過，就不枉此生。

鄧淑明博士太平紳士 Dr. Winnie Tang, JP.
Esri 中國（香港）有限公司創辦人及主席
香港大學工程學院計算機科學系、社會科學學院地理系及建築學院客席教授
2021 年 12 月

天道酬勤

當何廣暢兄邀請我為他的新書《追夢者的樂園》寫序的時候，我感到既榮幸，亦感到戰戰兢兢。自問比不上何兄的成就，但是，我深受他的新書，透過攝影藝術，去道出人生中的變化而感動。作者鼓勵我們如何享受人生，並繼續向前追求人生的理想和目標。

我謹在此分享我的小小經歷，以及對人生的一點看法，希望和《追夢者的樂園》的讀者分享。

我和何兄一樣，家人在自己年青時已移民海外，但我並沒有跟隨他們，而是決定留在香港發展。當時是我剛大學畢業、開始工作才兩年。我當時認為我在亞洲會有較大的事業發展機會。又或者不想被典型的移民發展所定型。當我事業剛起步的時候，剛好遇到 1997 移民潮，對於在 1988 年畢業的我，的確帶來很多晉升的機會。我一直抱有了解公司大方向的工作態度，以便更能了解為什麼某些工作會落在我身上，及如何將它做得更好。我想這種工作態度，曾為我帶來很多工作上的機會。

至於年青人對升學及就業方面，我知道有一些成功的家長會分享他們對培育兒女教育的一套策略，例如如何升讀長春籐大學等等。我對兒女讀書的看法是，最重要是他們可以入讀到他們喜歡的科目。對我來說讀書是一生的事情，大學

學位，尤其是第一個學位，只是個開始。我想最好是兒女喜歡的科目。因為，往後他們會有很多機會進修。畢竟，我一直相信終身學習這個概念。

在這裏我分享一個我跟我兒子小時候的小故事。當時他大約有七至八歲大。有天他問我，他長大後應該做什麼工作。我當時對他說，兒子，你將來所做的，或許今天還未發生。今天我所做的工作，到你長大後，可能已不存在。所以我們討論這個問題可能沒有什麼意義。重要的是，他要學會如何發問問題，因為發問問題能夠讓他獲取一個答案。在這個答案的基礎上，他可以發問下一個更好的問題，如是者他會從中得到下一個更好的答案，並因此在某方面有進步。其實，我當時所說的，是所謂的研究的精神。當然，向一位七歲小朋友來討論研究精神未免太深奧，但告訴他如何發問問題也許他比較容易明白。我相信，小朋友必須要懂得發問問題，以及了解追查真相的精神。因這個技巧，能夠陪伴他們的一生。

回顧我一生的讀書及就業的發展，我可以稱得上是一位幸運兒，因為我想得到的，或早或晚都能達到。我並不是說我今天的成就可以比得上何兄，更談不上什麼的成就。但以我小時候的出身，今天可以說是對父母輩有所交代。我小時候不是不懂讀書，而是不懂考試。我記得我很喜歡閱讀課外書，但不知怎樣我總是不能適應香港的考試制度，不懂得有效率地，集中地，去背誦考試範圍內的資料。有所謂高分低能，或許我是低分高能的佼佼者。說到真正懂得享受讀書，及在讀書中找到方法，要去到我半工讀碩士學位的時候才出現。及後，我有幸能夠於 45 歲前完成我其中一個夢想，能夠讀到一個博士學位，可以講得是超額完成。我知道我父母自少都對我的學業發展非常擔心。或許，他們從沒有想過，他們的兒子能夠大學畢業，進而拿取碩士及博士學位。

這一切，我認為，我有點像龜兔賽跑裏的龜，開始時總是落後於別人，但我一直沒有放棄以龜速不斷向前，最終達到目的地。別人也許看不起途中某些挑戰，或深信自己不能達標，我身邊很多同行夥伴，都或早或晚放低了向前的動力。

我在社會裏工作了大約 30 多個年頭，我一直相信要在自身崗位上作出貢獻，必須要了解如何創造價值。如果各人都抱有此種態度，我相信機構的效率自然會大大提升。距離我退休大約還有 10 或 15 年左右，我仍然計劃或期盼工作上能夠更上一層樓。同時我亦為日後半退休作過一些構想。我希望日後能夠作為公司的獨立非執行董事，為各種企業出謀和獻策，同時亦希望可以在大學中作研究及教學，這便能夠報答我前輩對我的支持唯有在我伸手可及的後輩中，能夠分享我的一些經驗。

司徒聖豪博士 Dr. Martin Szeto

首席營運總監，香港應用科技研究院有限公司
2021 年 12 月

God rewards hard work

When Peter Ho invited me to prepare a preface for his new book, "TREASURE ISLAND: THE ADVENTURES OF A DREAMER", I felt extremely honoured. I am deeply impressed by Peter's way of expressing the life changes – by fusing his talent in photography, and his unreserved sharing of his successful career endeavour–in searching for his own dream. Peter encourages us to enjoy life and continue to pursue our ideals and goals in life.

Along this line, to echo Peter's work, I would like to complement with my little story and my point of view towards life, hoping to share with the readers.

Like Peter, my family had immigrated overseas when I was young, but instead of following my family, I decided to stay in Hong Kong. It was when I graduated from university and started working for only two years. I thought I would have greater career development opportunities in Asia. Or maybe I was overwhelmed by immigrants' typical lifestyle and career developments. When I just started my career in the 80s, I happened to encounter the 1997 immigration wave – the brain drain. For me, who graduated in 1988, it did bring many opportunities for promotion. I have always wanted to understand the general direction of the company so that I can better understand why certain tasks fall on me and how to do it better. I think this working attitude has allowed me to learn a lot.

Below I would like to share my opinion about helping my children in planning their studies and start their career.

I know that some successful parents will share their strategies such as how to progress to Ivy League universities. My opinion on children's education is that the most important thing is that they can study the subjects they like. For me, studying is a lifelong matter. A university degree, especially the first degree, is just the beginning. I think the best subjects are the subjects that children like. Because, in the future, they will have many opportunities to further their studies. I am a firm believer in the concept of lifelong learning.

Here I share a little story between me and my son. When he was about seven to eight years old, one day he asked me what job he should do when he grows up. I said to him, son, what you will do in the future may not happen today. The work I did today may no longer exist when you grow up. It may not make much sense for us to discuss this matter. What makes sense to you, son, is to learn how to ask questions, because asking questions will allow you to get an answer. Based on this answer, you can ask the next better question, so on and so forth. You will definitely make progress in certain areas. In fact, what I was talking about was the method of research. Of course, it may be too difficult to expect a seven-year-old child to appreciate the research spirit, but it might be easier for him to understand how to ask questions. I believe that children must know how to ask questions and understand the spirit of pursuing the truth. This is a life-long skill that will be accompanying our kid throughout his lifetime.

Looking back on the development of my own studies and employment throughout, I must admit that I am a lucky person because I have achieved what I want and I know it is only a matter of time if I am not there yet. I'm not saying that my achievements today are comparable to Peter's, but when considering where I started, I can say that I have achieved a lot that would make my parents feel proud. When I was young, it was not that I didn't know how to study, but I didn't know how to take exams. I remember that I like reading extracurricular books, but somehow, I can't adapt to Hong Kong's examination system. I don't know how to memorize materials within the scope of the examination

efficiently and intensively. Speaking of truly knowing how to enjoy studying, it didn't appear until I was studying for a master's degree. Later, I was fortunate to be able to complete one of my dreams – to acquire a doctorate degree before age 45. I know that my parents have been very worried about my academic development since I was young. Perhaps, they never thought that their son would be able to graduate from university and then get a master's and doctorate degrees.

All of this, I think, I am a bit like a tortoise in the tortoise and the hare race. I always am the one lagging at the beginning, but I never give up, keep moving forward at the speed of the tortoise, and finally reach my destination. Others may look down on some of the challenges on the way or be convinced that they cannot meet the challenges and give up. Many of my colleagues have sooner or later quit the race.

I commenced my career some 30 years ago, I have always believed that to contribute to my position, I must create value. I adopt this attitude on my first day of work naturally. I dare not say that this is the only way to succeed, but if everyone embraces This attitude, I believe that the efficiency of the organization will naturally be greatly improved.

It is about 10 or 15 years before I retire, and I still plan or look forward to achieving more. At the same time, I have also planned for semi-retirement, and when that day comes. I hope that in the future, I can serve as an independent non-executive director of a company as such I can continue to contribute to various businesses and industries. At the same time, I also hope that I can have opportunities to conduct research and teach in universities. Because I can repay my seniors' selfless support by helping the younger generations.

Dr. Martin Szeto
Chief Operating Officer,
Hong Kong Applied Science and Technology
Research Institute Co. Ltd.
https://www.linkedin.com/in/martinszeto
December, 2021

從厄運中尋找上天的啟示

想不到我在社交媒體的人生和業務分享，一點一滴地影響著世界各地的朋友，和 Peter 素未謀面，他就單憑我創辦鑽的和成功抗癌的經歷，邀請我為他的新書撰寫前序，這個虛擬世界真的有無窮力量，讓人類的共鳴可以像漣漪一樣不斷擴效延伸⋯⋯

2006 年 8 月尾一個晚上是我人生的分水嶺，我從一個只懂採訪和報導別人故事的社區新聞記者，開始變成說自己故事的輪椅人士照顧者。那天媽媽腦癌病發，右手嚴重抽筋跟著暈倒，我們急忙送她到醫院治理，後來證實她左腦長了超過兩厘米的神經膠質瘤。這是我人生第一次近距離認識「癌症」，也是第一次感到心如刀割，醫生說媽媽大約只有兩、三年壽命，她當時只有 58 歲。

人生的佈局，三分人為、七分天意，由呱呱落地一刻，很多成長環境也不是自己控制，這就是「天意」。上天給我安排了一個爸媽很努力工作的幸福小家庭，是典型在香港公屋長大的孩子，我們並不富有但家庭關係尤其我和媽媽的感情特別深厚，這就是當媽媽遇上人生最大厄運時的「人為」底氣。我知道，上天要我做點事回饋我最愛的媽媽，也為她早逝的人生留下寶貴的價值，讓善良的她可以持續遺愛人間。

有著照顧者和記者的雙重身分，我看到不止我媽媽，還有很多別人的爸爸媽媽和將來的自己，也很需要有尊嚴的無障礙生活，坐上輪椅不應是人生惡夢，反

而是閃耀的新旅程，條件就是我們的社會也懂得更專業地照顧輪椅人士。「鑽的」無障礙的士以鑽石命名，就是要提醒完全失去自信而喜愛鑽石的媽媽，她，永遠是我們最有價值的媽媽。鑽的創辦 11 年，數以萬計的輪椅乘客已經感受過這種無障礙出行的尊嚴和價值。媽媽最後一次乘搭鑽的是和她的媽媽、我的外婆共度母親節，她成功圓願，也應該感謝自己養育了一個像她一樣孝順的女兒。

過分投入鑽的工作而不自覺犧牲健康，上天又安排了我一嘗做乳癌病人的滋味。今次我看到的是，原來絕大部分乳癌病人也羞於啟齒，令這個病的成因、治療和康復等資訊也是一個謎，這樣令更多人沒有防範意識，甚至令患者錯失及時治療的機會。我知道，這次輪到我自己的人生厄運，就是上天要我填補這個資訊空間，於是由 2017 年 9 月確診乳癌開始，不間斷在 Facebook 專頁 Breast and Best 撰寫我的抗癌歷程。助人自助，原來分享故事也舒緩了我的情緒，繼續感謝上天的安排。

若果大家怕「追夢」的門檻太高或者茫無頭緒，就從自己的厄運中尋找上天的啟示吧，只要培養慈悲心和洞察力，堅持為社會帶來多點愛，屬於你自己的「夢想」便會活現眼前。

梁淑儀 Doris Leung
鑽的（香港）有限公司創辦人及行政總裁
2021 年 11 月

重要的說話說三遍

有寫序恐懼症。

就算是自己的食譜,也拖到最後一刻才敢動筆。與何廣暢先生素未謀面,他邀請我為他的攝影集《追夢者的樂園》寫序,我卻又答應了。

其一,這當然是我的榮幸。

其二,因為自小資質平庸,很自卑,所以從自小就經常看「自救(Self-help)」及有關追夢的書籍。後來,看多了才明白,因為每個人不同,夢想及經歷也不同,根本不可能以文字來表達。看文字用太多「腦」了。夢想不能用太多「腦」,可能越「無腦」越好。可能因為這樣,追夢者被人説「無腦」。

《追夢者的樂園》是一本攝影集,直接用照片與讀者的「心」溝通,有別於坊間一般追夢書籍,所以便答應寫序了。

後來何先生寄了攝影集的相片給我看,更證明自己的決定是正確的。看到照片後,心領神會,像與何先生是多年老朋友一樣。可能大家都是無腦的追夢者吧。

説了這麼多,我先介紹一下自己。

我名字叫 Grace,是一個廚師,拿菜刀多過拿筆,所以我不能用太多腦寫作,我盡量用心寫好這個序吧。

在我當廚師之前,是做文職的。

自小資質平庸,家境不富裕,媽媽守寡靠賣麻雀(賭具)養大六個孩子。媽媽和姐姐希望我過得安穩,供我到英國讀秘書課程。回香港後,理所當然是做秘書。

真的,做秘書收入好,工作穩定。

然而,生活的穩定,卻掩飾不到內心的不安。

做了文職幾年後,開始集中不到精神,每日只想等著放工回家做飯。

經理投訴我,準時放工會影響全組人士氣,但我也很厚面皮地不理她,繼續準時放工,繼續準時享受做飯的樂趣。

結果……

其實經理給我的壓力不是太大，因為我面皮太厚了，也太喜歡做飯了。但心裏真的很難受，因為家人辛辛苦苦供我讀書，就是想我做文職，過穩定的生活吧。

心裏掙扎，哪可能走去當廚師，更何況是一個女人。

所以一直在掙扎、掙扎再掙扎。

後來終於明白，家人最終的目的也只是想我生活得快快樂樂。追逐夢想最重要是自己的勇氣，其他的任何因素只是為了安定的藉口，不想跳出自己的舒適圈（Comfort Zone）吧。

現在我當了廚師，雖然沒有什麼很大成就，但對我而言，是快樂的，也吸引了很多本地及國際傳媒的訪問。

有趣的是，最初是訪問我的美食，最近卻很多傳媒及大學邀請我做講師，想聽聽我創業的故事。最初覺得，他們對我這麼感興趣，是因為我輸在起跑線，資質平庸，中年創業，也能成功地維持生意，同時追逐夢想。

看了何先生的資料及照片後，有了以下的共鳴。

夢是自己的，因有別於追求名利、等級，所以根本沒有對比，沒有所謂的跟人家對比的起跑線。

夢是自己的，只要有勇氣跳出自己的舒適圈，什麼時候都可以開始。

夢是自己的，沒有跟人家對比的起跑線，也沒有跟人家對比的終點及目標。因為作為追夢者，早已陶醉於夢。

蔡孫美華 Grace Choy

其創辦的餐館為 CNN 嚴選香港十佳私房菜
世界上最多粉絲的中餐館（Facebook 專頁坐擁 1,000,000+
忠實粉絲）
Twitter 第一位認可的大中華名廚
全球多間主要傳媒專訪
世界美食家大獎 —— 世界全佳女廚師食譜總冠軍
2021 年 11 月

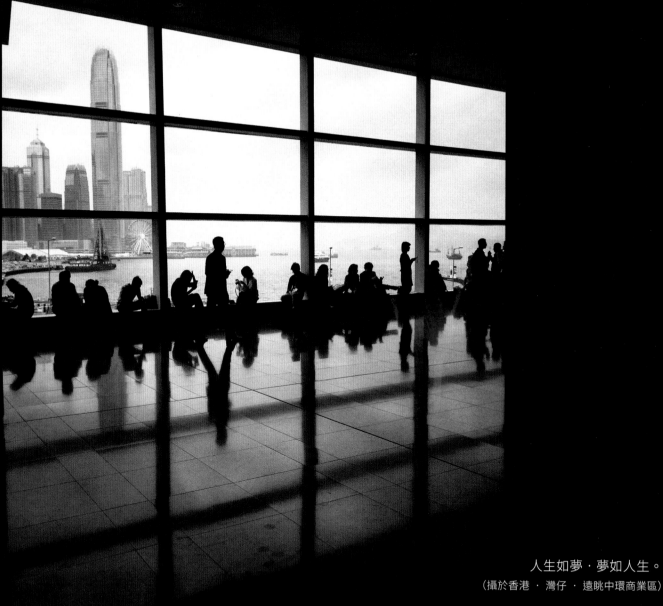

人生如夢・夢如人生。
（攝於香港 ・ 灣仔 ・ 遠眺中環商業區）

The most beautiful adventure you can take
is to live the life of your dreams.
(Lookout from Wan Chai to Central business district, Hong Kong)

人生如夢・夢如人生

今年六十四歲。時光倒流四十年，一九八一年剛大學畢業，夢想成真，往後六年亂闖亂撞，遊走於港加影視娛樂廣告界。對於一個滿腦子夢想創作、精力旺盛的年青人而言，編、導、演、日以繼夜的多媒體創作生涯實在太好玩啊！感恩。

男兒三十，當頭棒喝，毅然將追夢思緒、凌雲壯志轉換時空，飛躍到金融投資銀行界。命運就是如斯無法預料，往後瞓身一幹就是三十二年，亦是遊走於不斷高速進化的港加兩地。回顧一生浪漫情懷，鍾情陶醉在生於斯、長於斯的家鄉緣夢。

二〇二〇年決定辭任財經界。三十年來無間斷的自我嚴格審查、超高度自律的專業投資銀行生活模式，終來個大解脫，畫上休止符，重獲自由身。人生探索、追夢創作就緊接成為精彩人生下半場的奇妙動力，瞬間喜見人生三百六十度視點亮麗浮現。

《追夢者的樂園》創作靈感源自二〇一四年至二〇一九年在港期間，心血來潮，探索港九新界離島多處充滿夢幻感覺場景，奇妙捕捉時地人影像靈魂，更深入感受到香港人堅毅、奮鬥、精靈、創意、關愛、情懷等極盡感性的浪漫詩意畫面張力。

離任追夢三十年、身經百戰的金融財經水平線後，追夢成為傑出攝影作家，通過心靈勵志攝影書集與讀者分享追夢人生的奇遇壯志、心靈開懷及福杯滿溢感受，達到一個影像，心靈點亮。願影像予讀者強烈反思，抒寫勵志金句，更增強彼此思緒共鳴。

作為一個鍾情攝影藝術超越五十年的發燒友，感恩能通過構圖奇妙地將攝影捕捉的「一刹那」釋放，推動讀者思路更見全方位，更富想像空間。

親愛的讀者，《追夢者的樂園》正好反映自己在人生旅程中不斷進化、進取、進步。逆流順流，逝去歲月不會再回頭。享受追夢人生，尋找自己、自我探索，深信大家都可以成功步上更美麗豐盛的生命旅程。Dream Bigger. Be Vibrant, Be You. 共勉之。

何廣暢 Peter K.C. Ho
2022 年 1 月

目錄 Contents

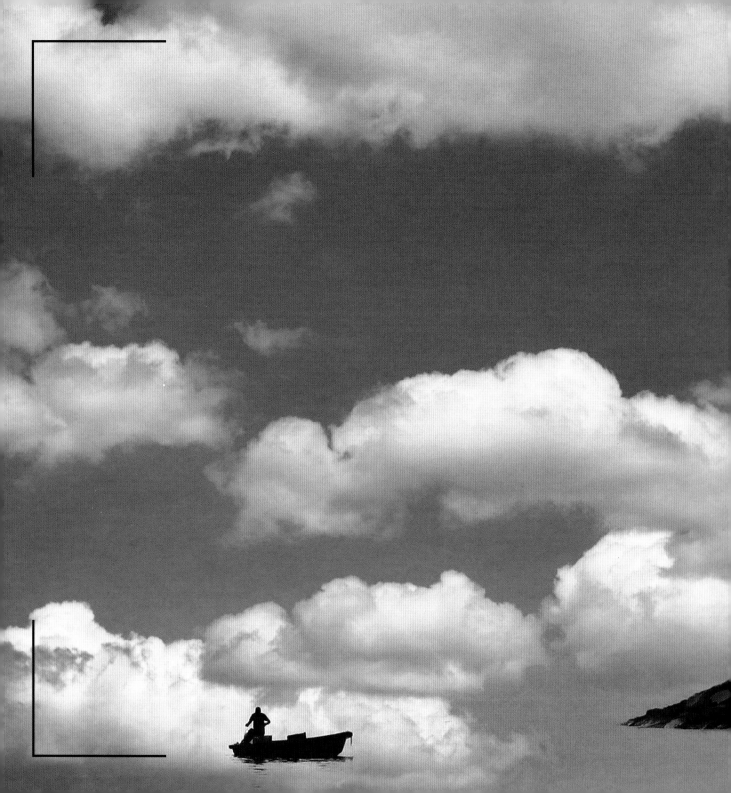

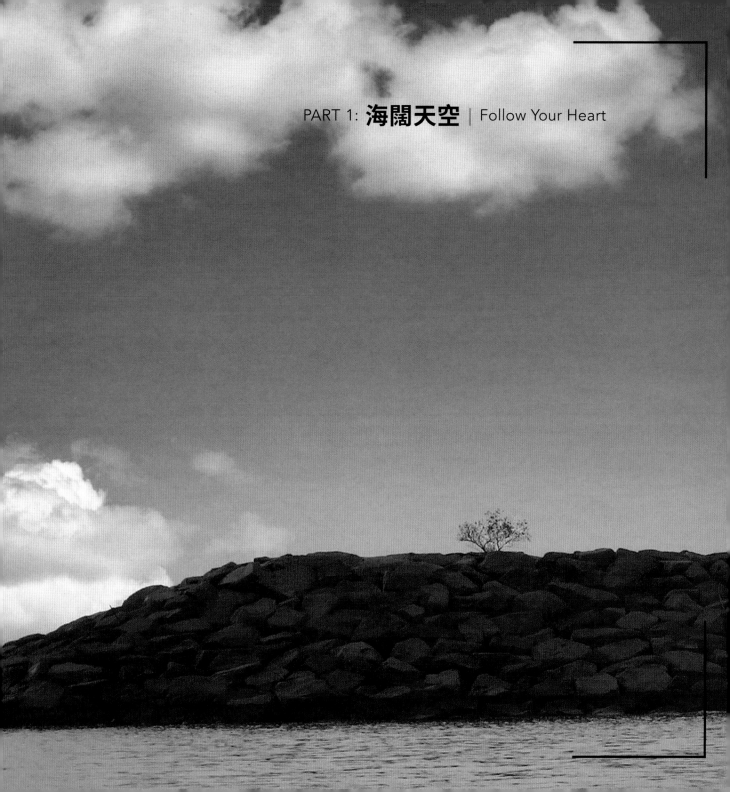

PART 1: **海闊天空** | Follow Your Heart

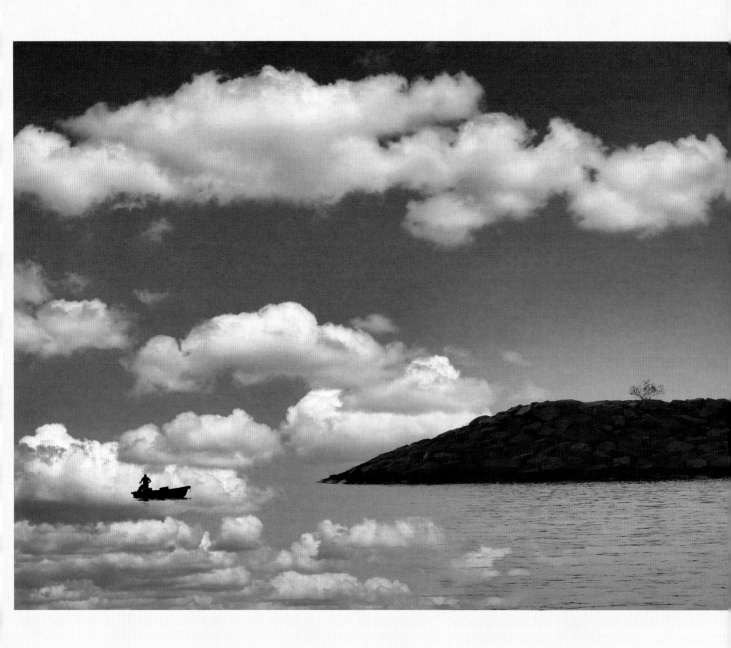

海闊天空・神采飛揚。So fun, so good!!

（攝於香港・大澳）

Follow your heart. Sea to sky adventures.

(Tai O, Hong Kong)

無盡的愛。
（攝於加拿大・多倫多）

From here to eternity.
(Toronto, Canada)

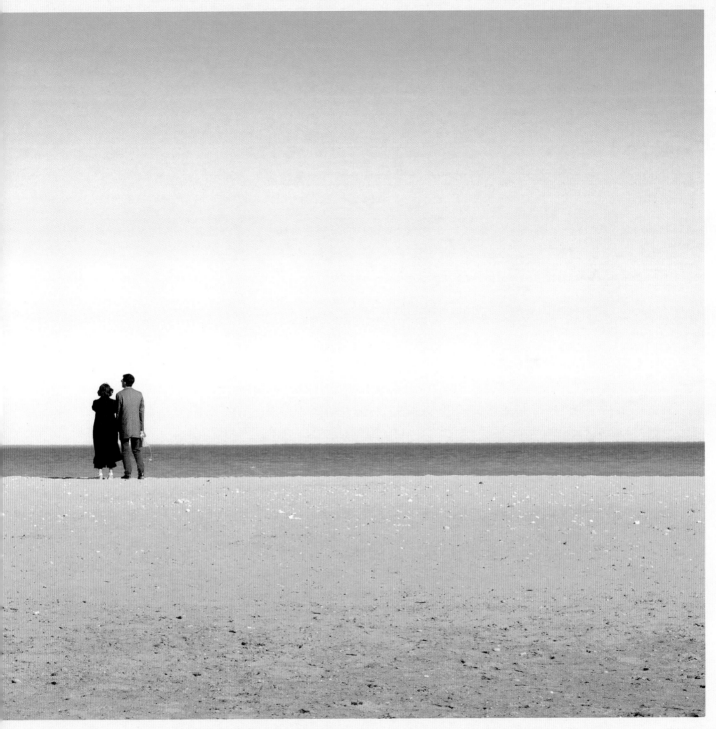

命運中的那一半。
（攝於加拿大 · 安省 · 心湖）

My destiny, my fantasy.
(Heart Lake, Ontario, Canada)

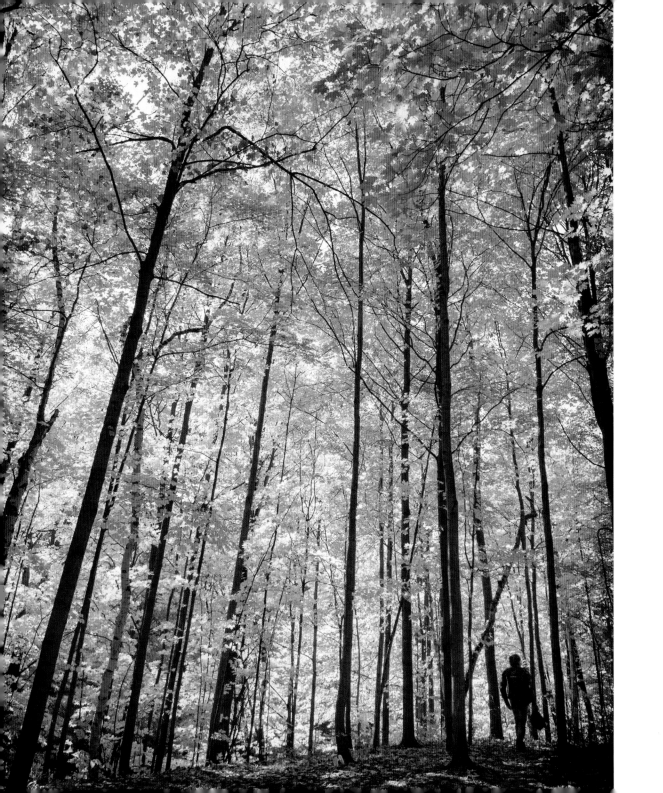

愛情的感覺。
（攝於香港・赤柱）

Guess I'm in love.
(Stanley, Hong Kong)

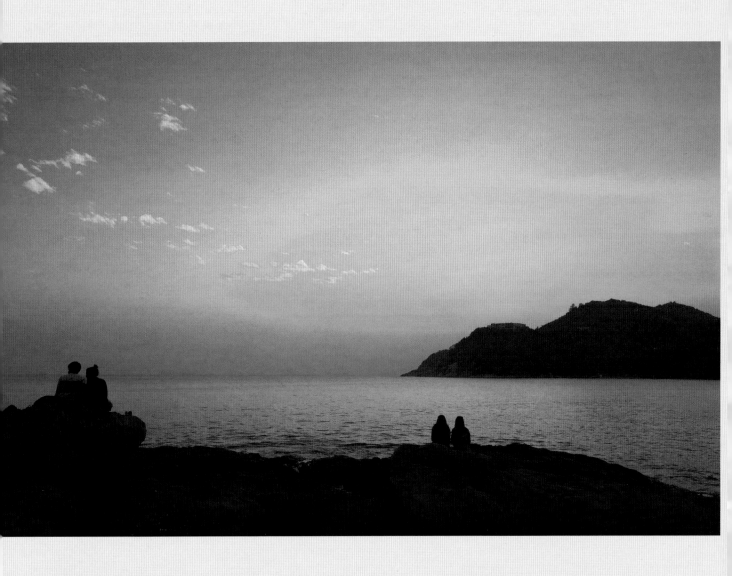

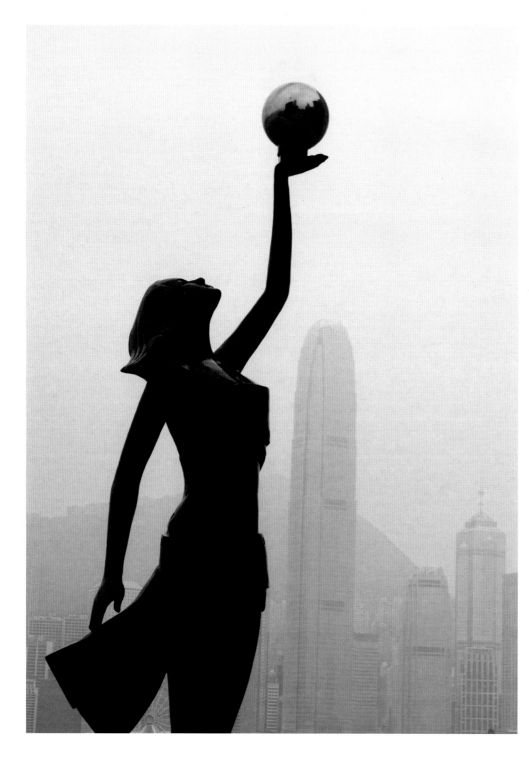

青春向前。
（攝於香港・尖沙咀）

Inspire the future and move on.
(Tsim Sha Tsui, Hong Kong)

人生馬拉松。
（攝於加拿大‧多倫多）

Life is an adventure.
(Toronto, Canada)

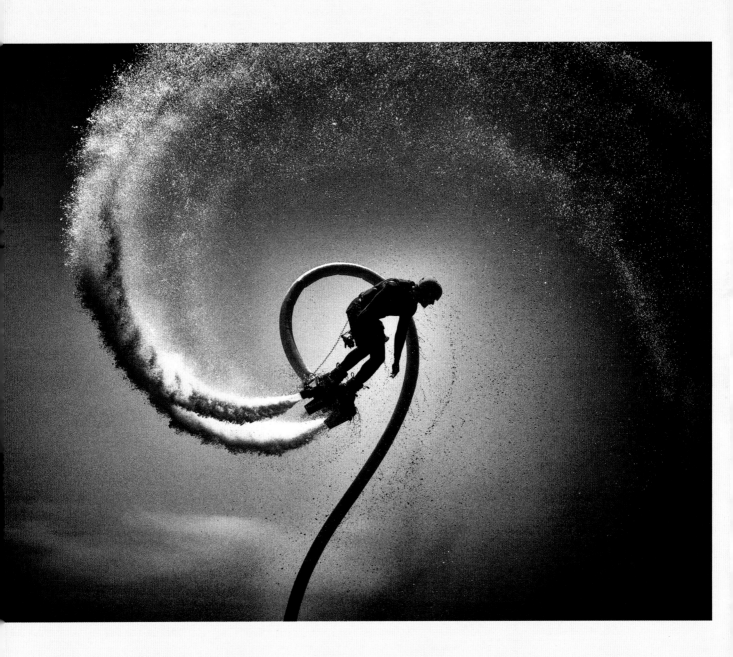

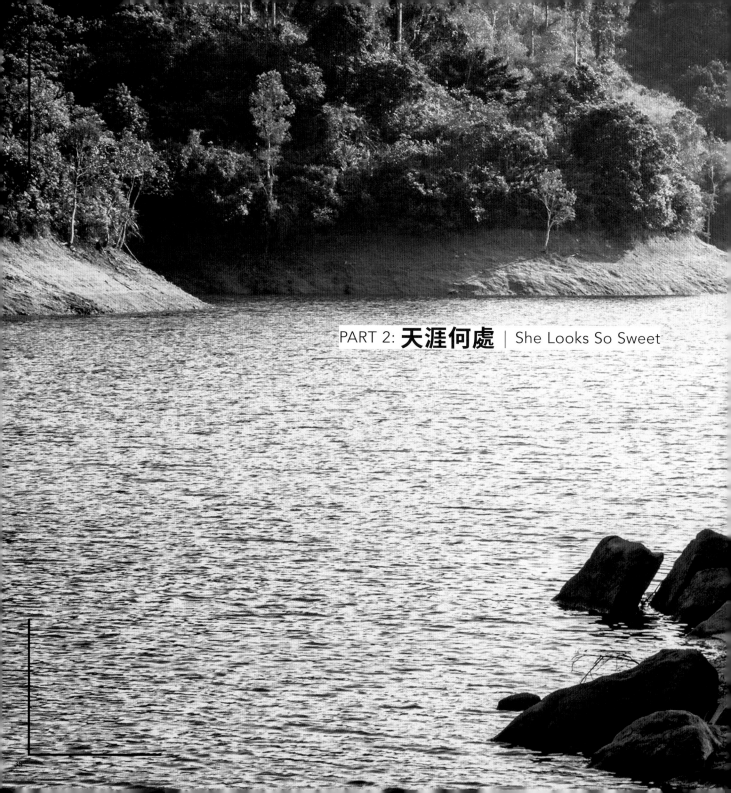

PART 2: **天涯何處** | She Looks So Sweet

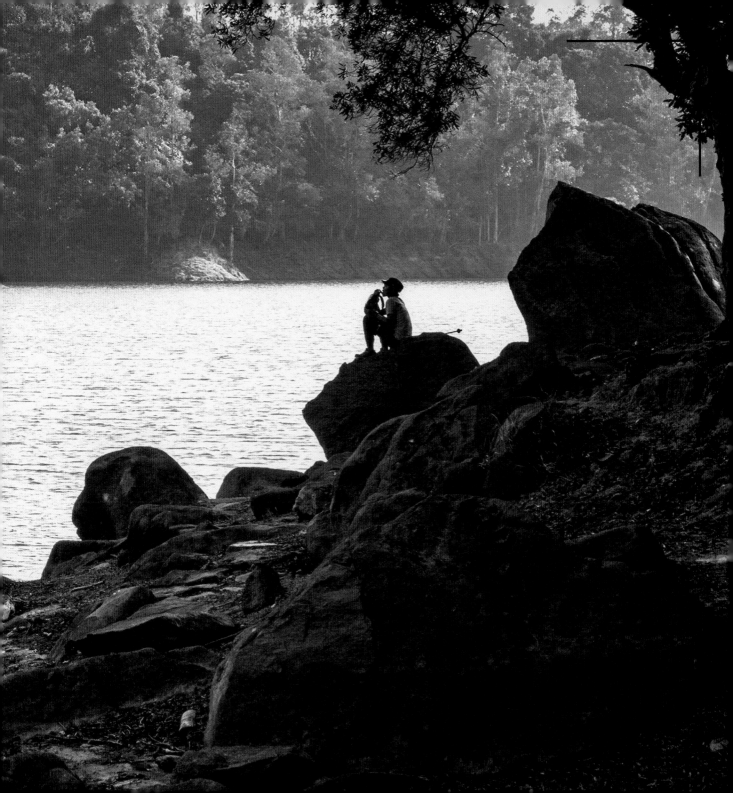

天涯何處·覓相逢。人生舞台·舞台人生？
（攝於香港·灣仔）

She looks so sweet. Is life a romantic fantasy or a sad melodrama?
(Wan Chai, Hong Kong)

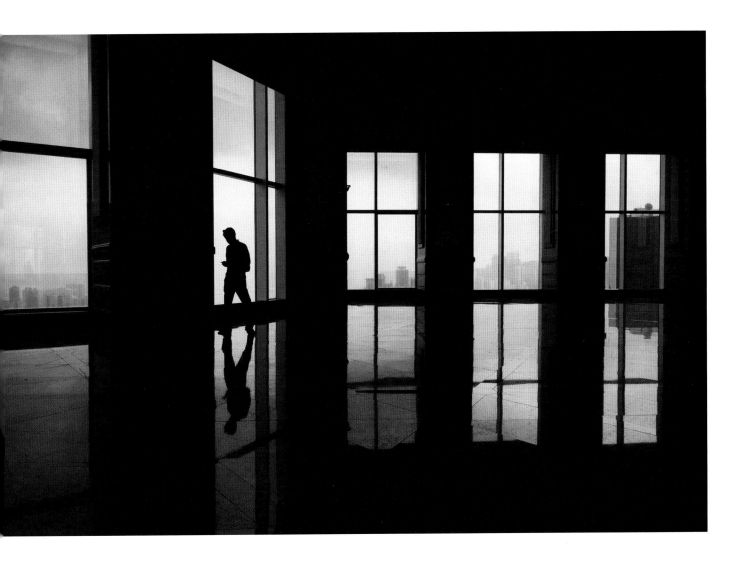

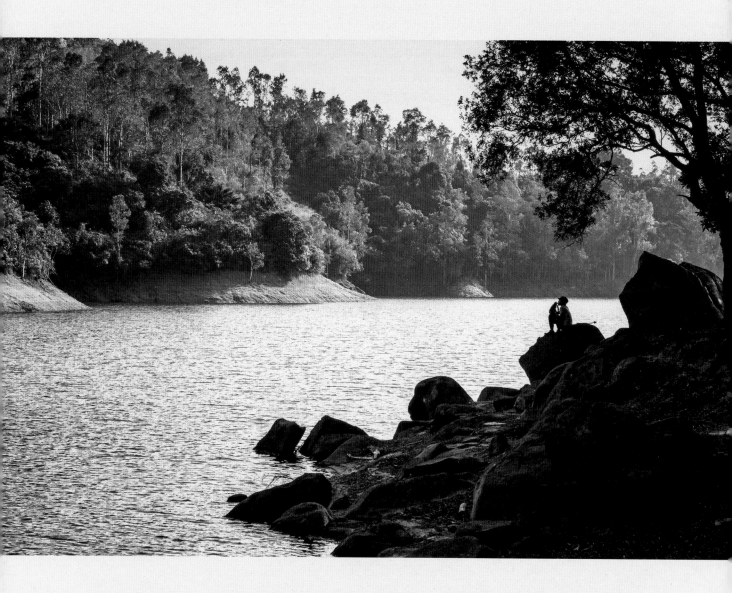

男兒有淚。
（攝於香港・城門水塘）

Day and night.
(Shing Mun Reservoir, Hong Kong)

美麗的旋律。

（攝於加拿大・多倫多）

Melody fair.

(Toronto, Canada)

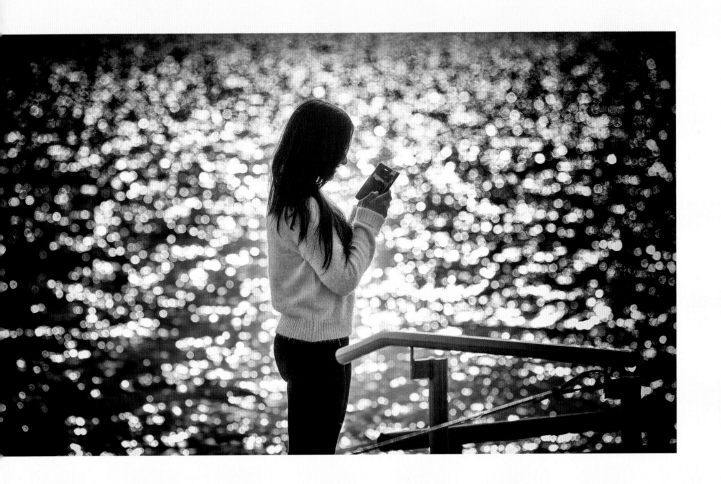

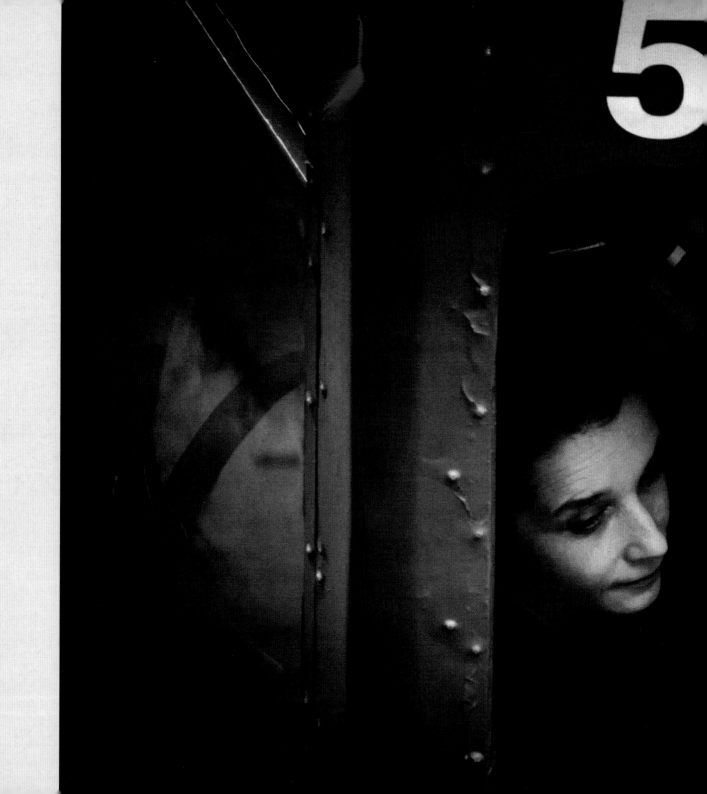

半生緣。

（攝於香港・銅鑼灣）

A streetcar named Desire.

(Causeway Bay, Hong Kong)

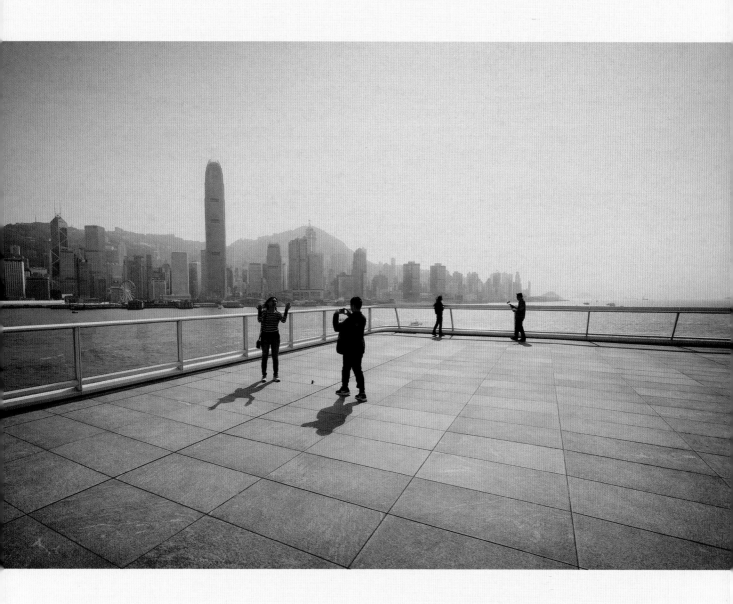

再遇上。
（攝於香港・尖沙咀・遠眺維港）

So happy together.
(Lookout from Tsim Sha Tsui. Panorama of Victoria Harbour, Hong Kong)

欣賞生命的陣痛。

（攝於日本・東京）

Beautiful dreams, beautiful pain.

(Tokyo, Japan)

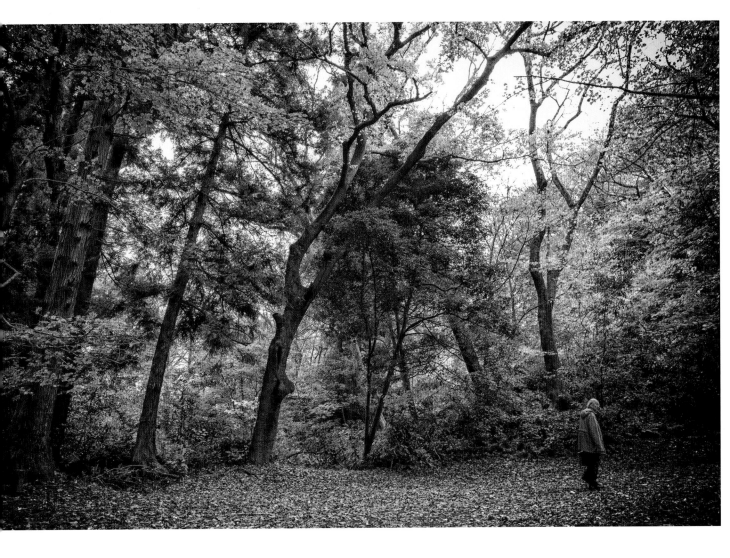

PART 3: **悲歡離合** | Happier Than Ever

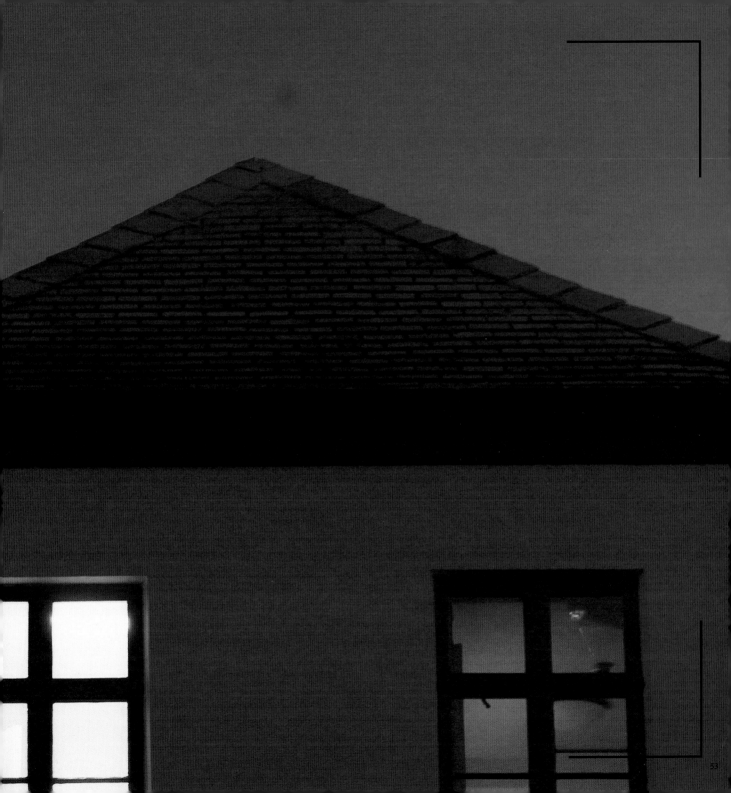

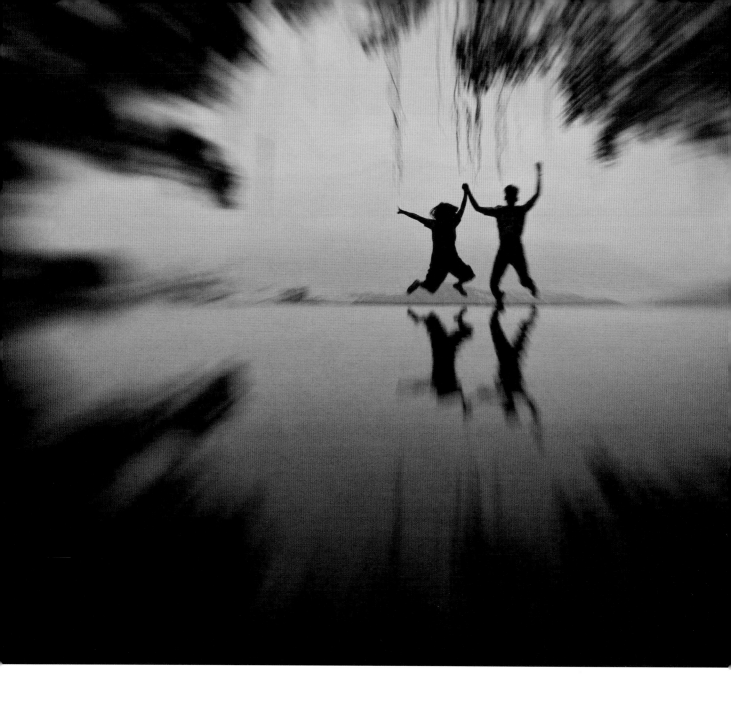

悲歡離合．人間歡笑。人生苦短．活在當下。
(攝於香港．中文大學．合一亭)

Happier than ever. Be vibrant, be you.
(Pavilion of Harmony, Chinese University of Hong Kong)

不畏懼，路即在眼前。

（攝於冰島·雷克雅未克）

Light of hope.

(Reykjavik, Iceland)

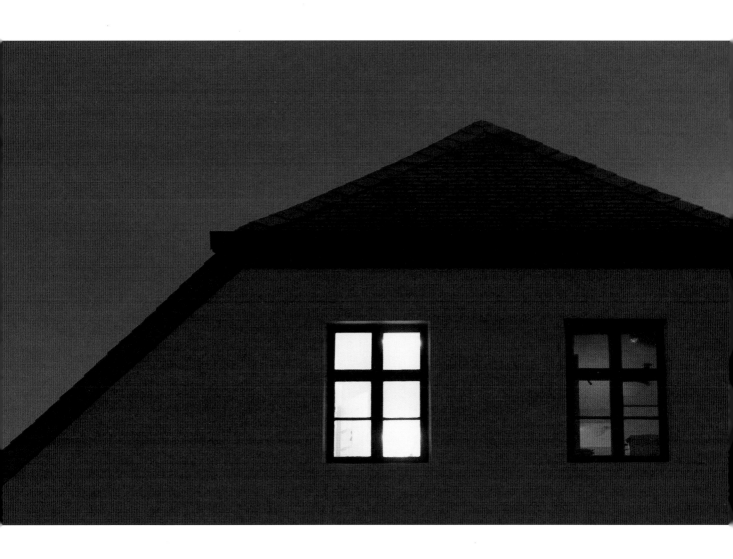

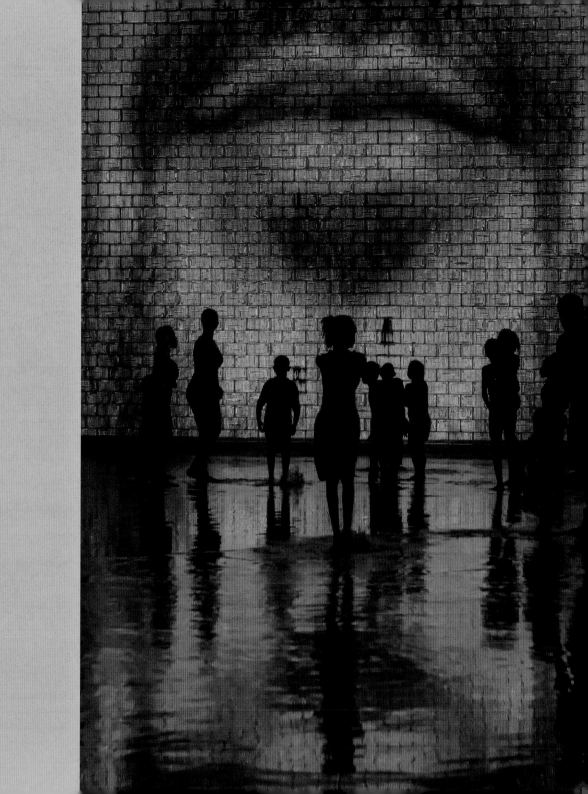

夢。
（攝於美國・芝加哥）

Hope is a waking dream.
(Chicago, USA)

蘇軾《水調歌頭》:「人有悲歡離合,月有陰晴圓缺,此事古難全。」
(攝於香港・灣仔)

Wish you were here.
(Wan Chai, Hong Kong)

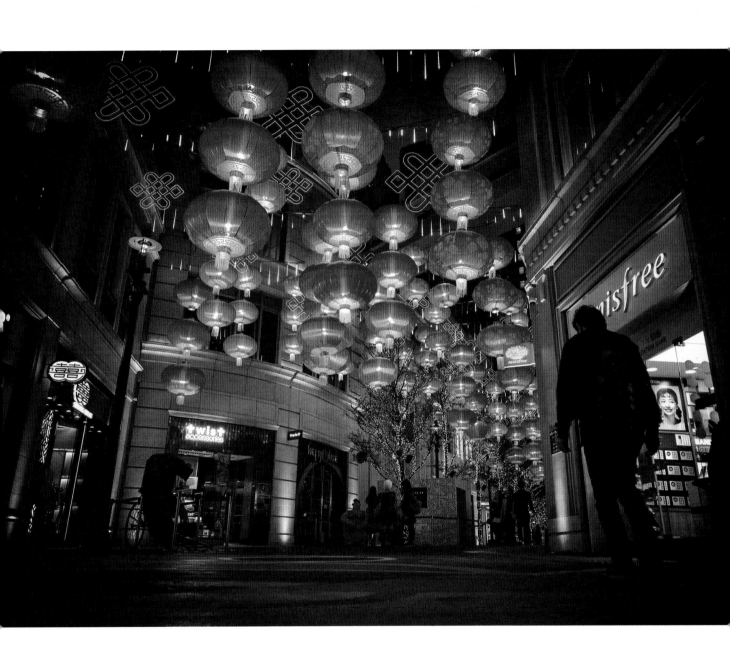

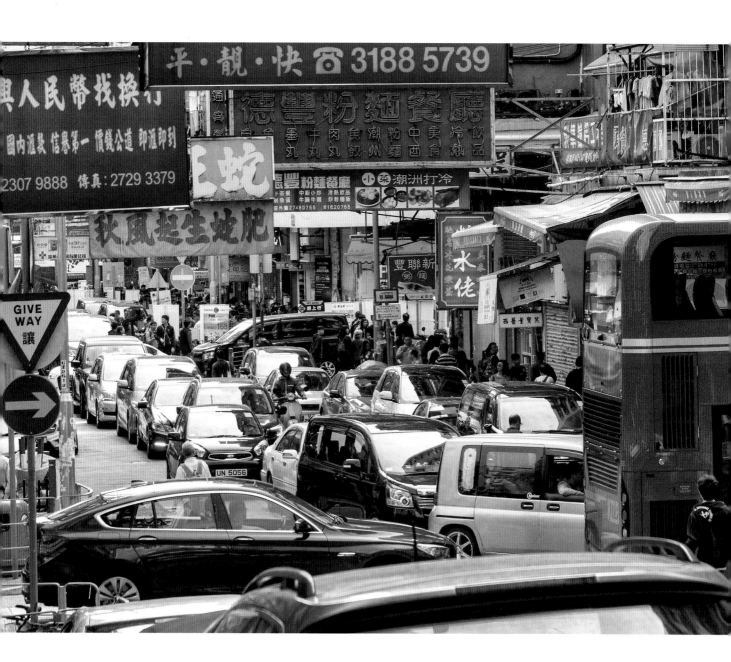

人生無常，把握當下。
（攝於香港・九龍・深水埗）

Crisis and opportunity.
(Sham Shui Po, Kowloon, Hong Kong)

香江緣夢，刻在心底的名字。

（攝於加拿大‧多倫多）

Dreams are my beautiful reality.

(Toronto, Canada)

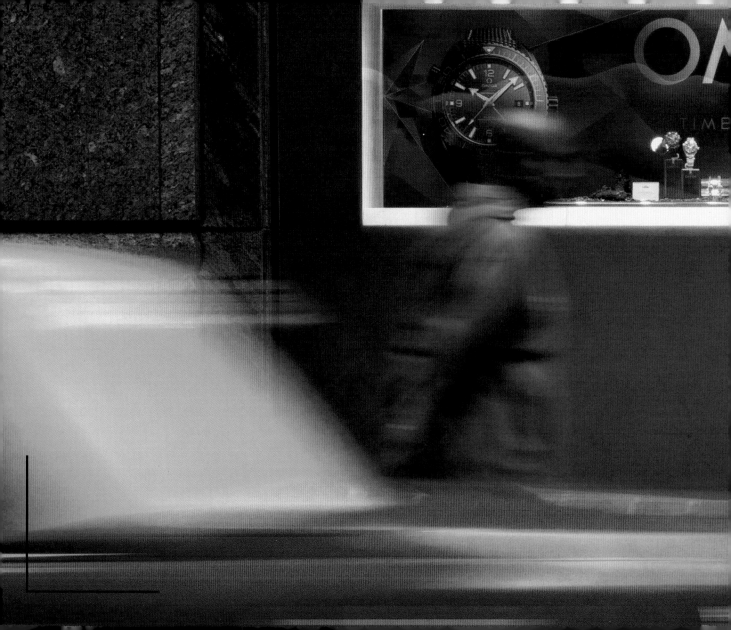

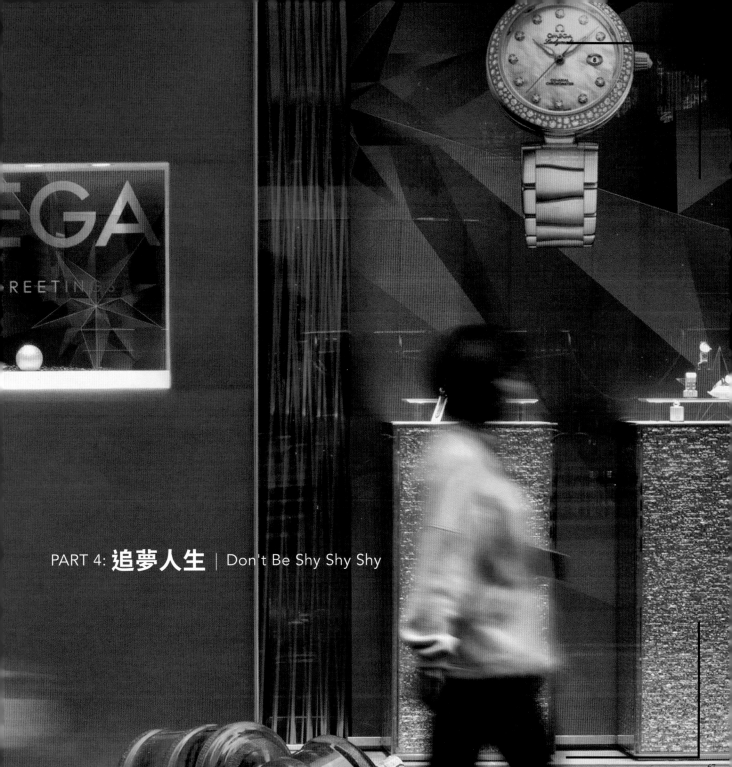

PART 4: **追夢人生** | Don't Be Shy Shy Shy

追夢人生，畫出彩虹。
（攝於香港・萬宜水庫・東壩）

Don't be shy shy shy. Chase your dreams.
(High Island Reservoir East Dam, Hong Kong)

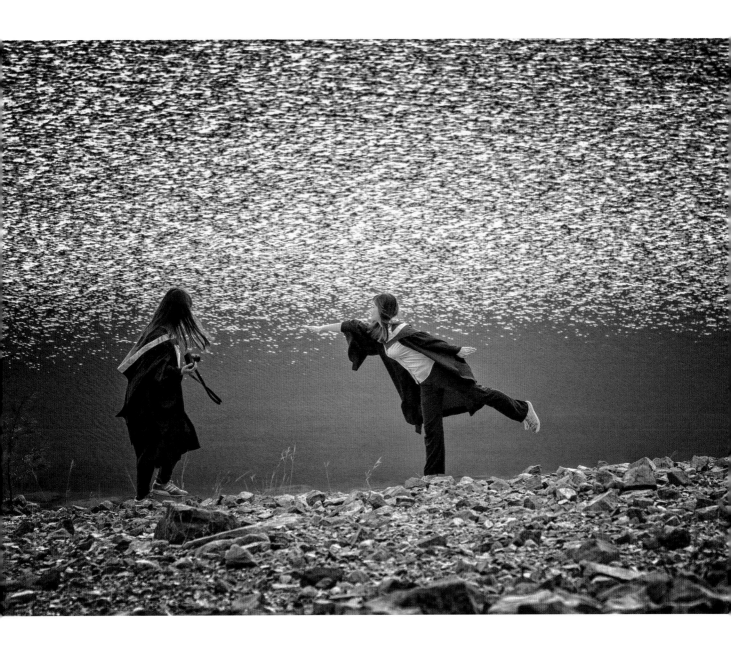

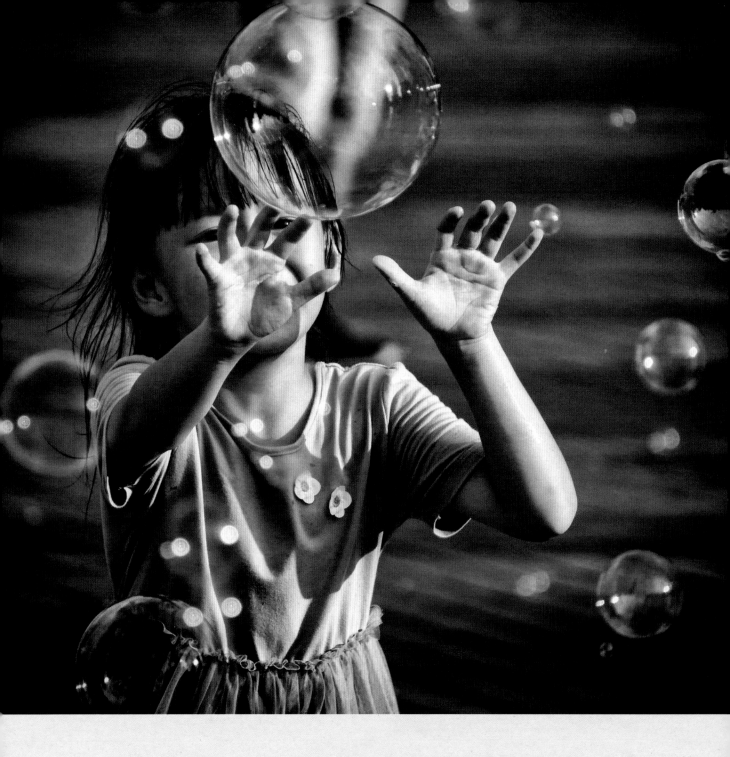

最緊要好玩 !!
（攝於香港‧中環）

Pursuit of happiness.
(Central, Hong Kong)

一人有一個夢想。
（攝於香港·銅鑼灣）

Children are the future.
(Causeway Bay, Hong Kong)

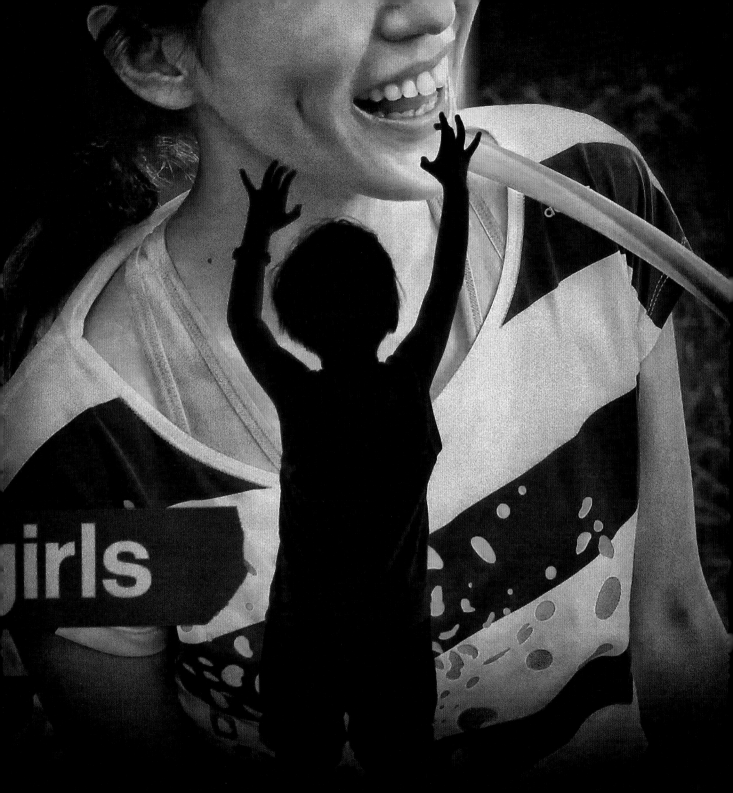

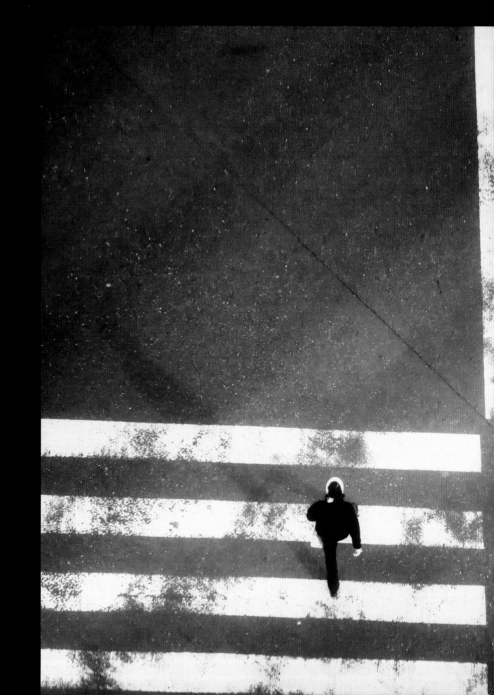

夢想成真。
（攝於日本・東京・銀座）

My dreams come true.
(Ginza, Tokyo, Japan)

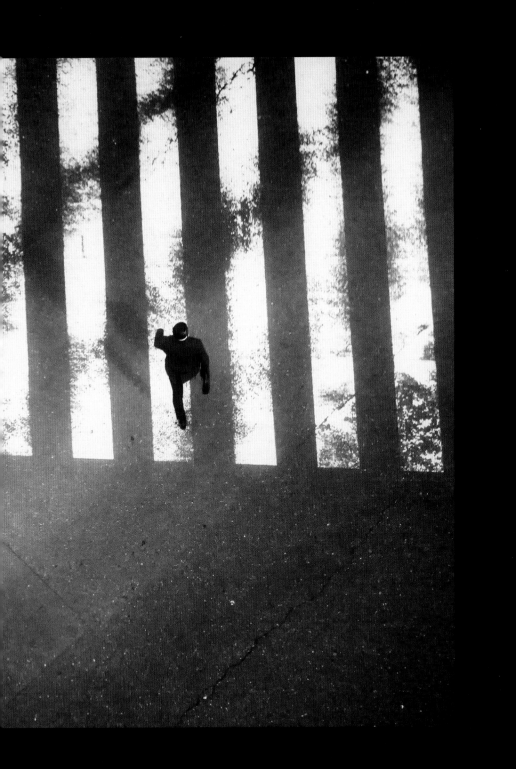

只有一個心願，真的嗎？
（攝於香港·中環商業區）

Temptation and happiness?
(Central business district, Hong Kong)

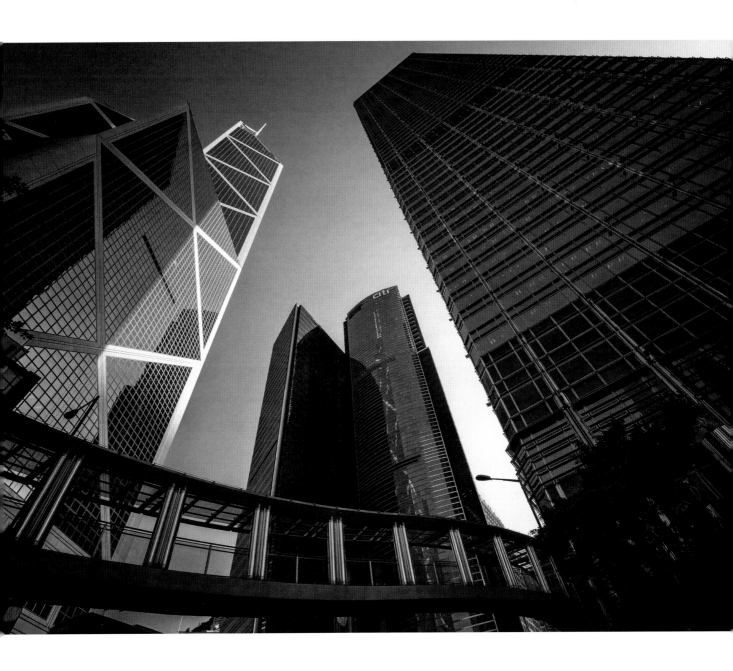

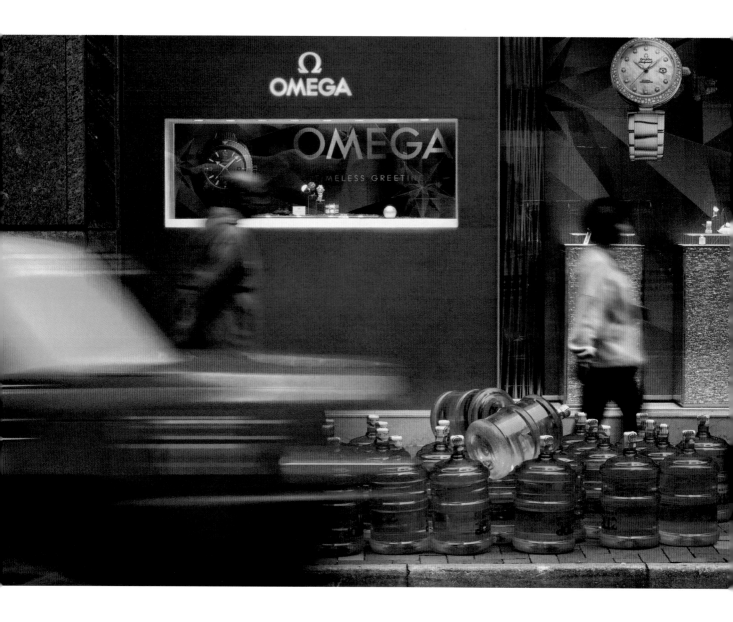

生命的循環。
（攝於香港・銅鑼灣）

Life is a circle game.
(Causeway Bay, Hong Kong)

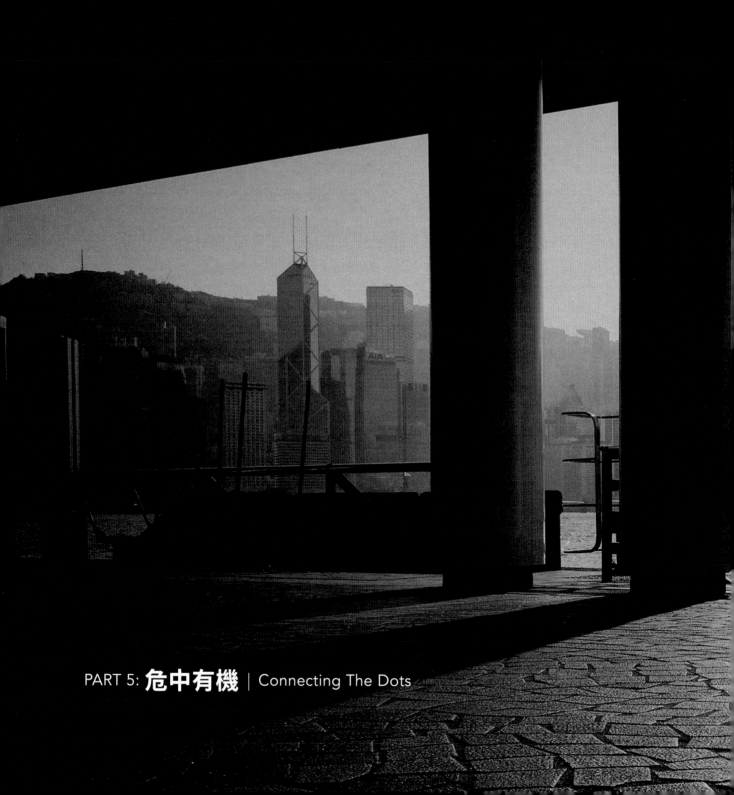

PART 5: **危中有機** | Connecting The Dots

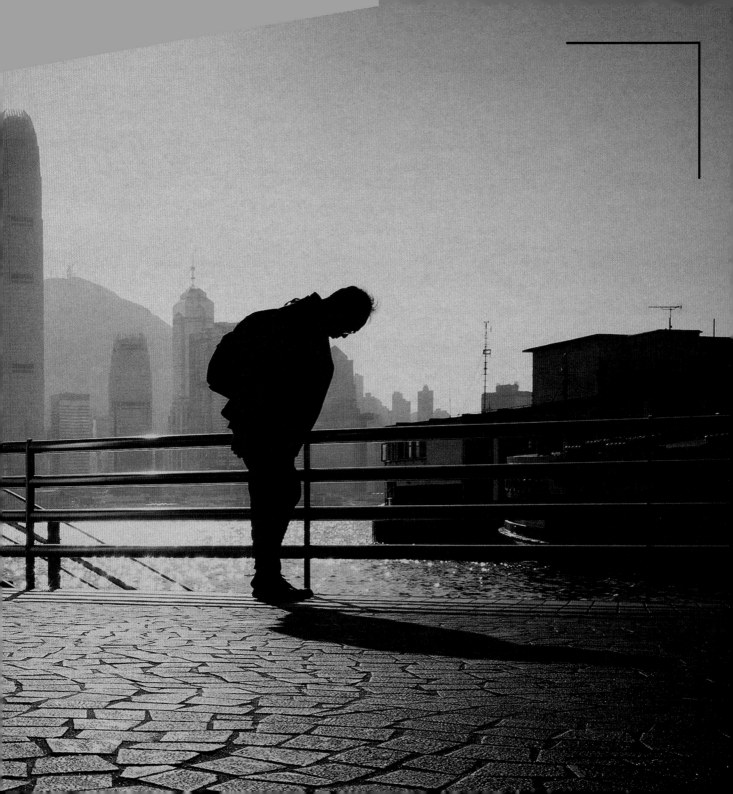

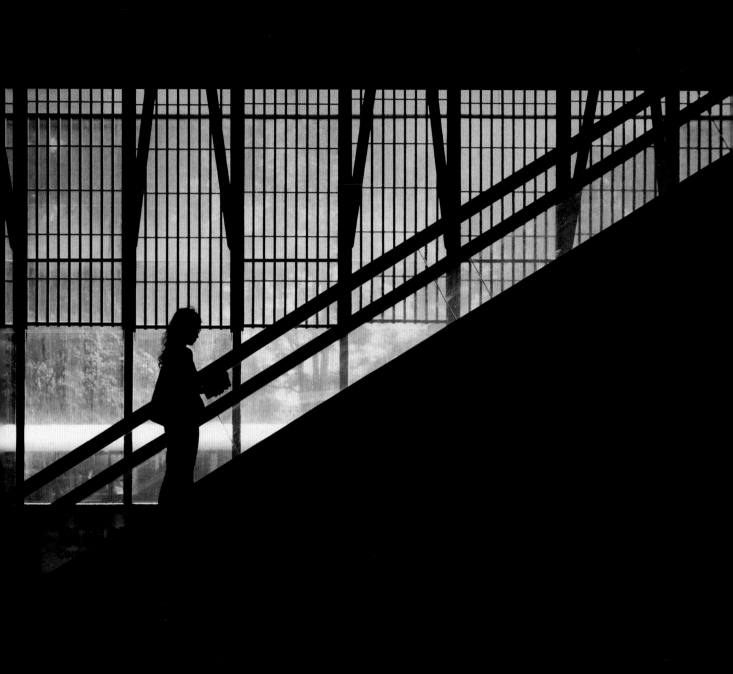

危中有機・前路。

（攝於香港・中環商業區）

Connecting the dots. Is life an escalator?

(Central business district, Hong Kong)

天生我材必有用。
(攝於香港・尖沙咀・遠眺中環商業區)

My beautiful mistakes.
(Lookout from Tsim Sha Tsui to Central business district, Hong Kong)

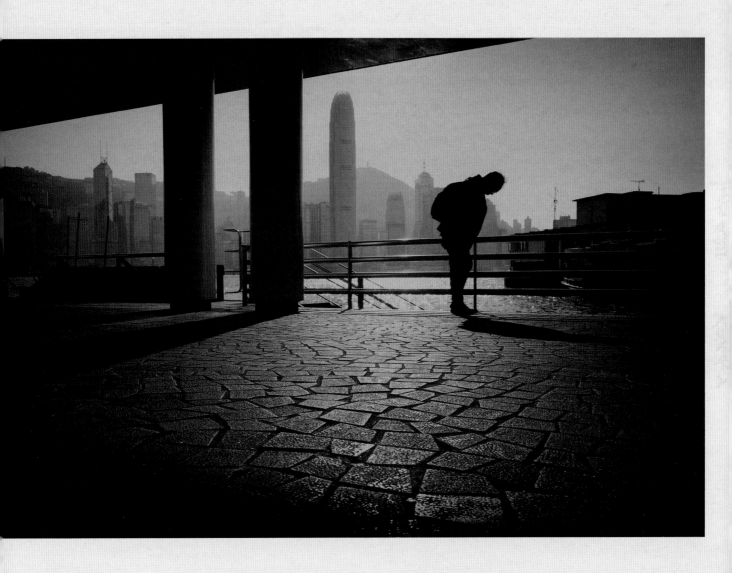

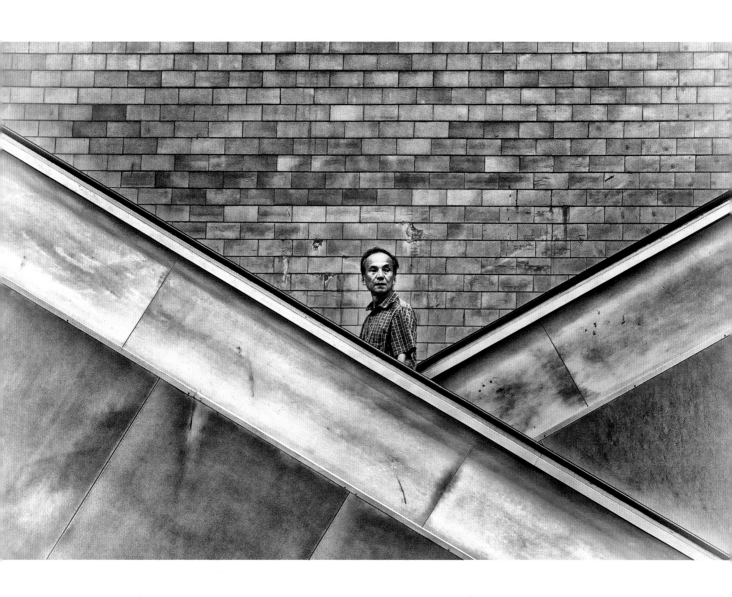

人生交叉點。
(攝於香港・中環)

Life's a jigsaw puzzle with most of the pieces missing?
(Central, Hong Kong)

人生拼搏，何懼風雨。
（攝於香港‧中環商業區）

All we have in life is now!!
(Central business district, Hong Kong)

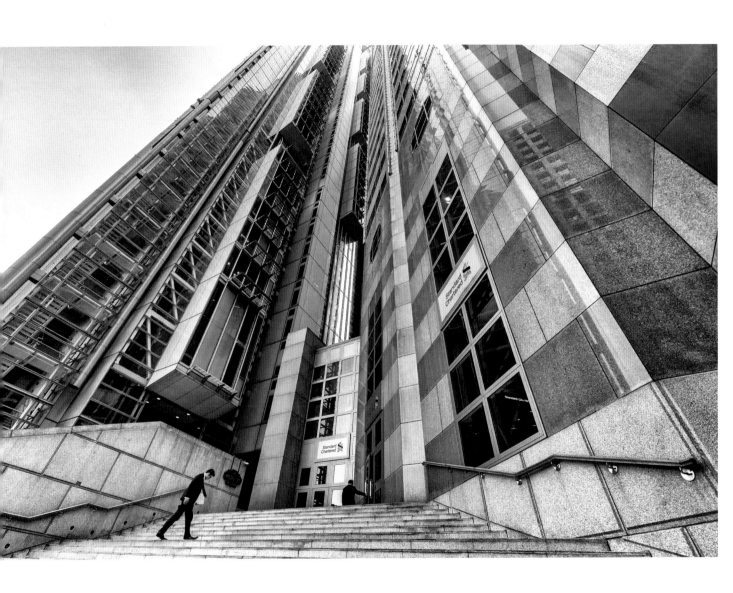

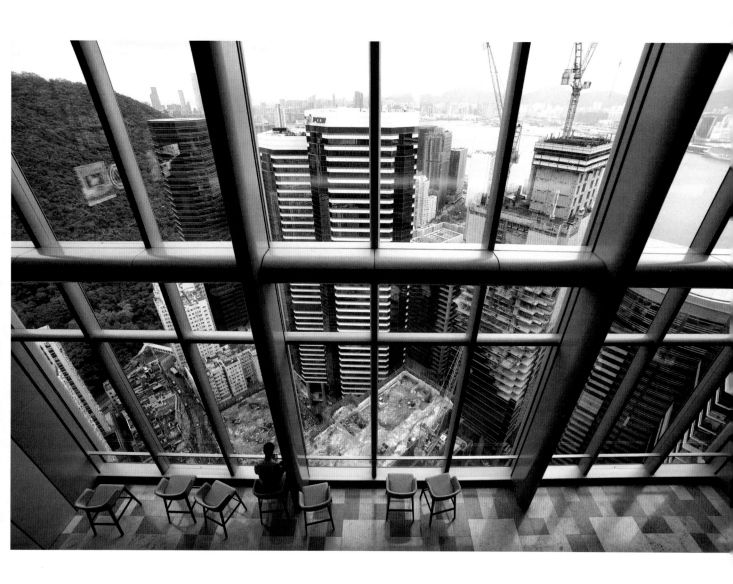

人生轉角位，當機立斷。

（攝於香港・鰂魚涌）

The only constant in life is change.

(Quarry Bay, Hong Kong)

珍惜‧感恩。
（攝於香港‧灣仔）

Life is magic.
(Wan Chai, Hong Kong)

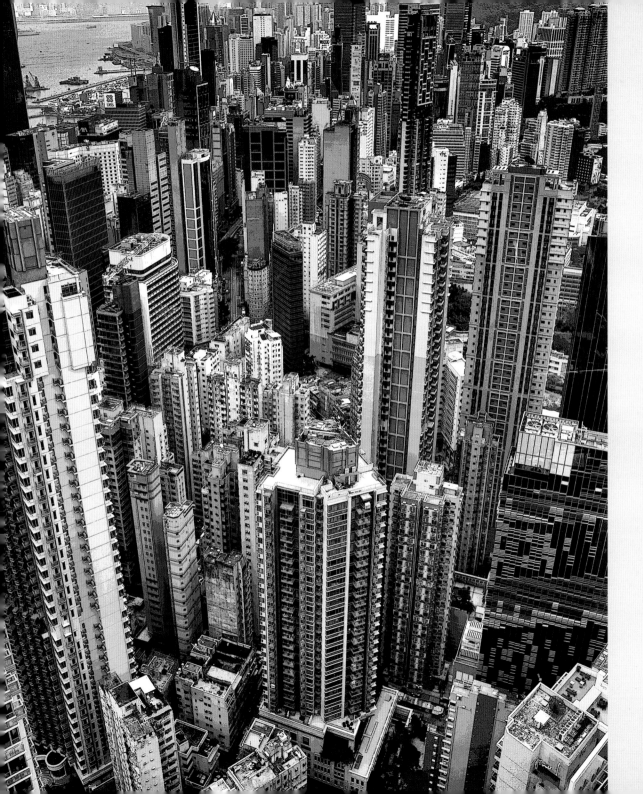

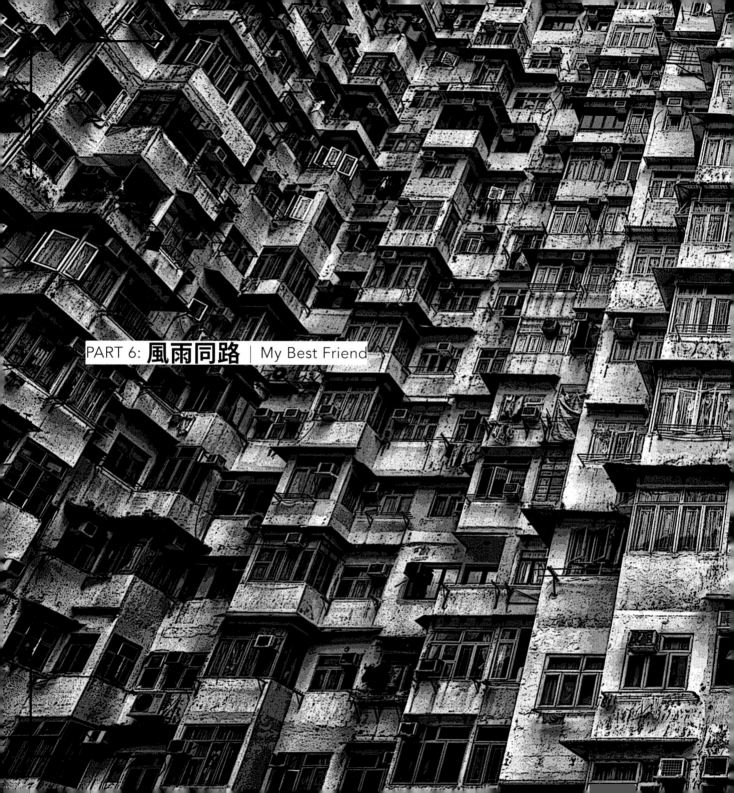

PART 6: 風雨同路 | My Best Friend

風雨同路。友情、愛情、親情。

（攝於加拿大‧多倫多）

My best friend. All bonds are built on trust. Without it, we have nothing.

(Toronto, Canada)

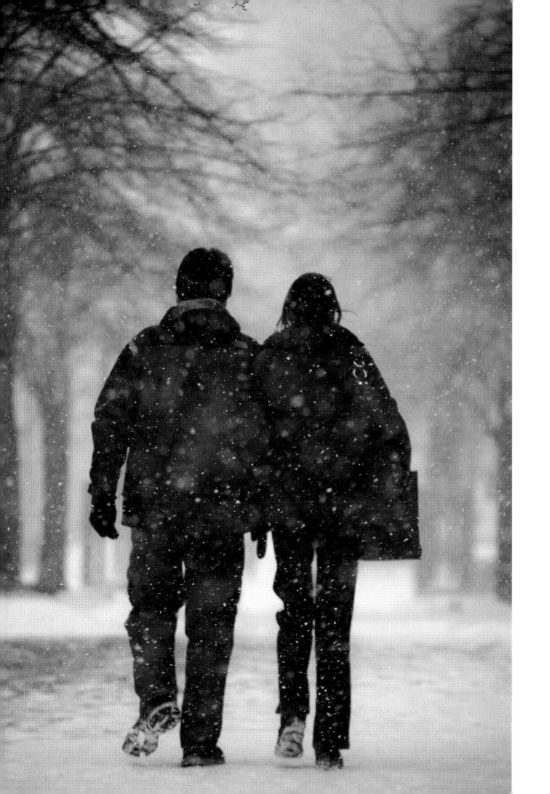

目標決定成敗？
（攝於香港 · 中環）

We won't give up.
(Central, Hong Kong)

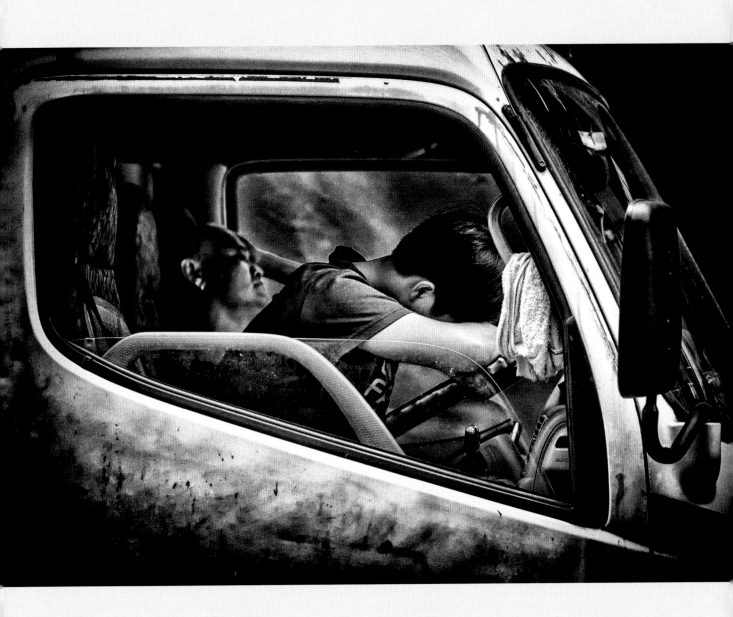

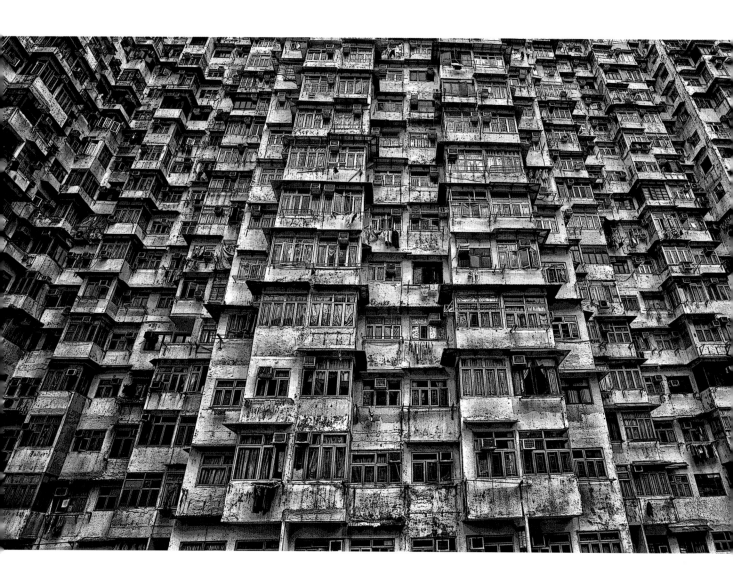

吃得苦中苦。

（攝於香港·鰂魚涌）

Courage and survival in difficult times.

(Quarry Bay, Hong Kong)

情人的眼淚。
（攝於郵輪旅程中）

No road is long with great caring company.

(On board a cruise ship)

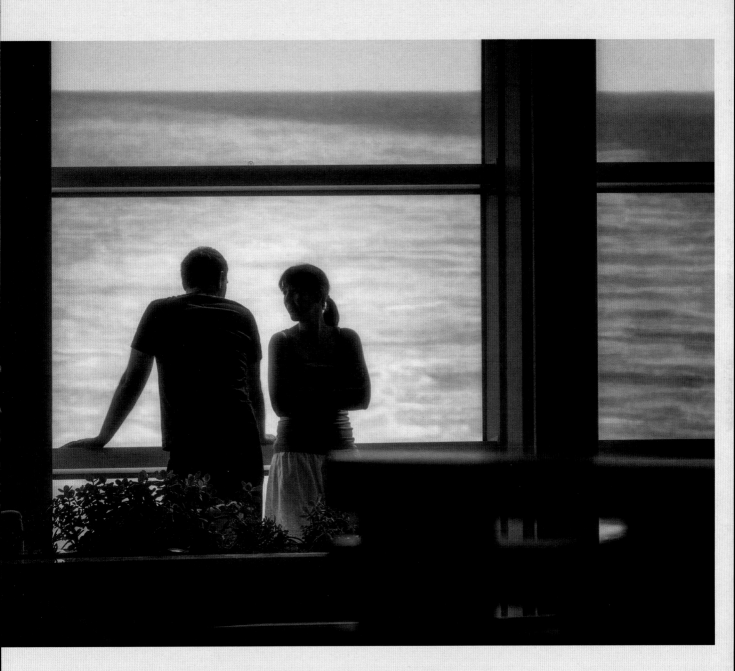

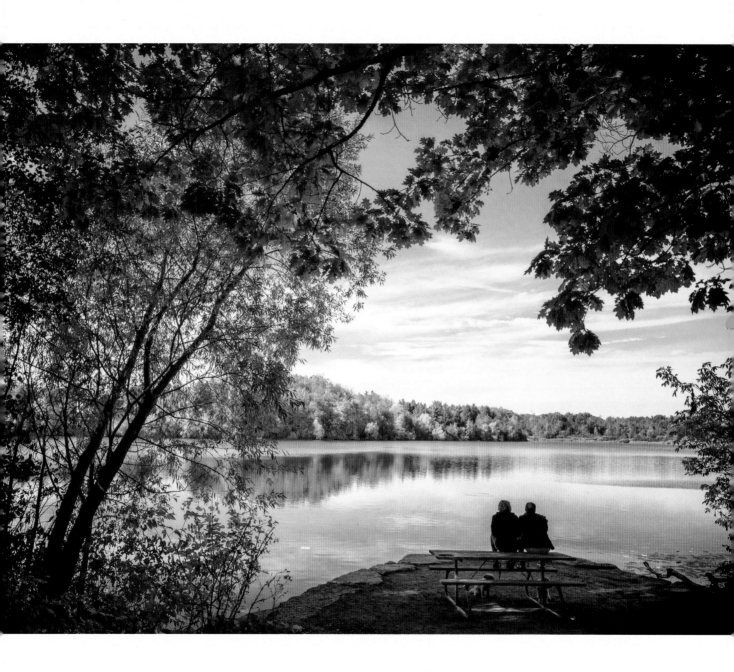

美麗的相逢。
（攝於加拿大・安省・心湖）

Happy together in spirit.
(Heart Lake, Ontario, Canada)

海內存知己，天涯若比鄰。

（攝於加拿大・多倫多）

Friendship is God's gift to us.

(Toronto, Canada)

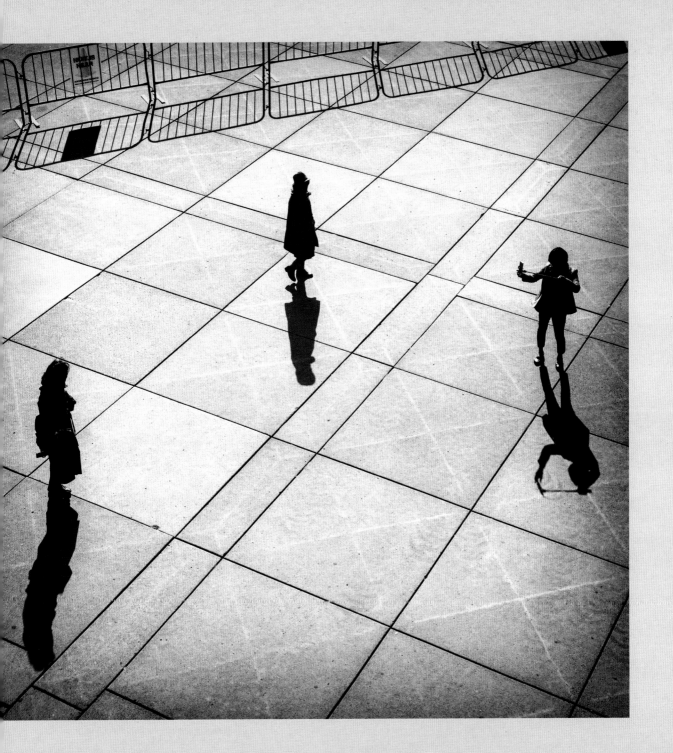

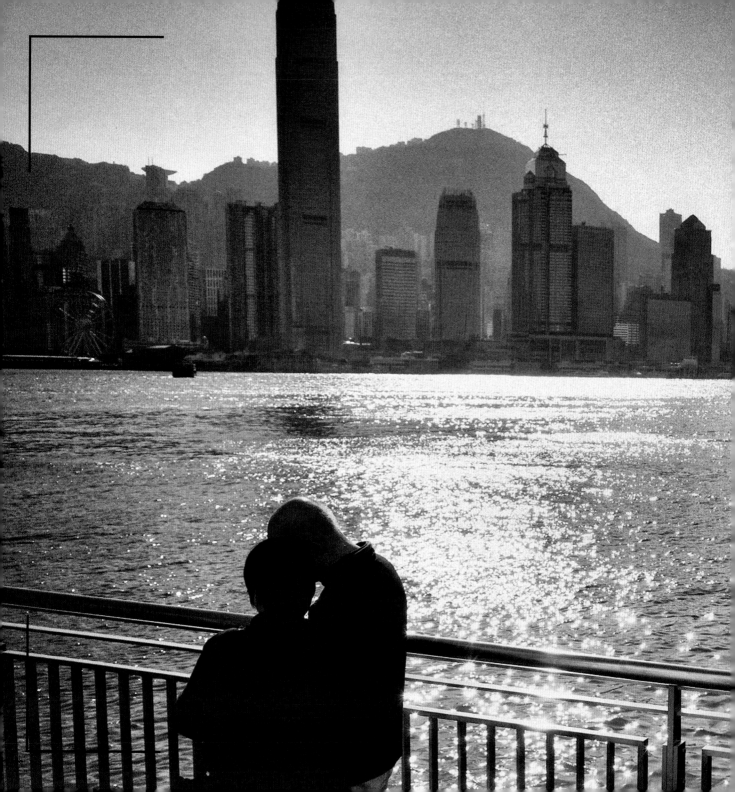

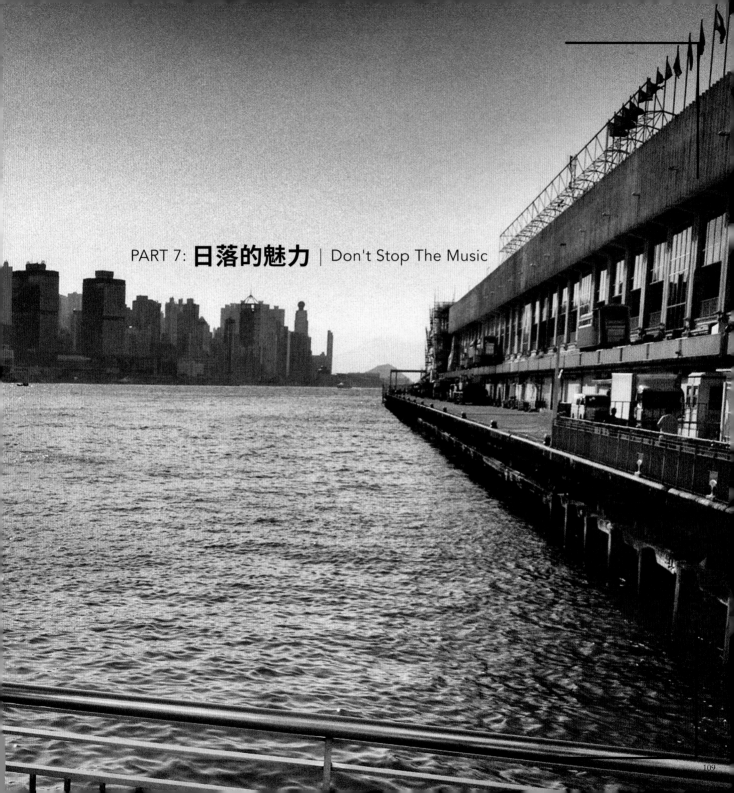

PART 7: **日落的魅力** | Don't Stop The Music

日落的魅力，精彩人生信望愛。

（攝於美國・三藩市）

Don't stop the music. With every sunset, a new beautiful hope is born.

(San Francisco, USA)

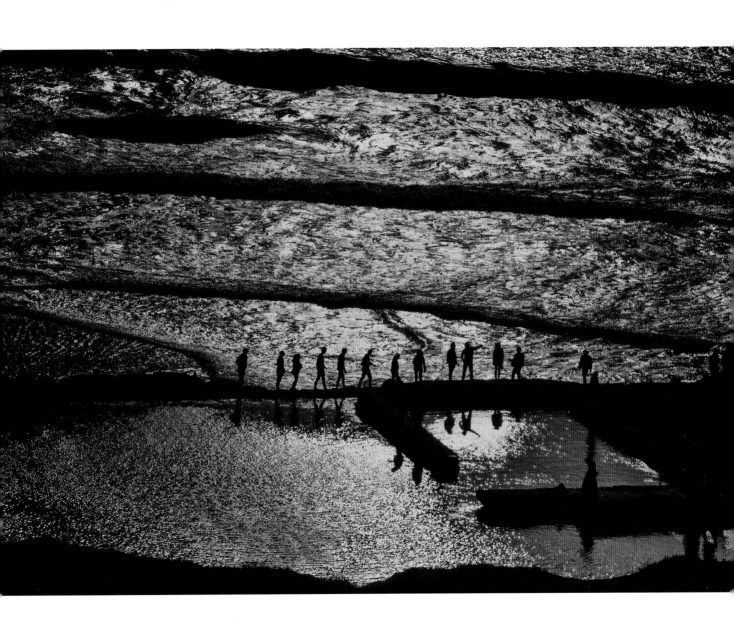

緣。

When the sun goes down, the stars come out magically!

生命是旅程。

(攝於香港・九龍・尖沙咀・遠眺維港)

Dream chasers.

(Lookout from Tsim Sha Tsui to Victoria Harbour, Hong Kong)

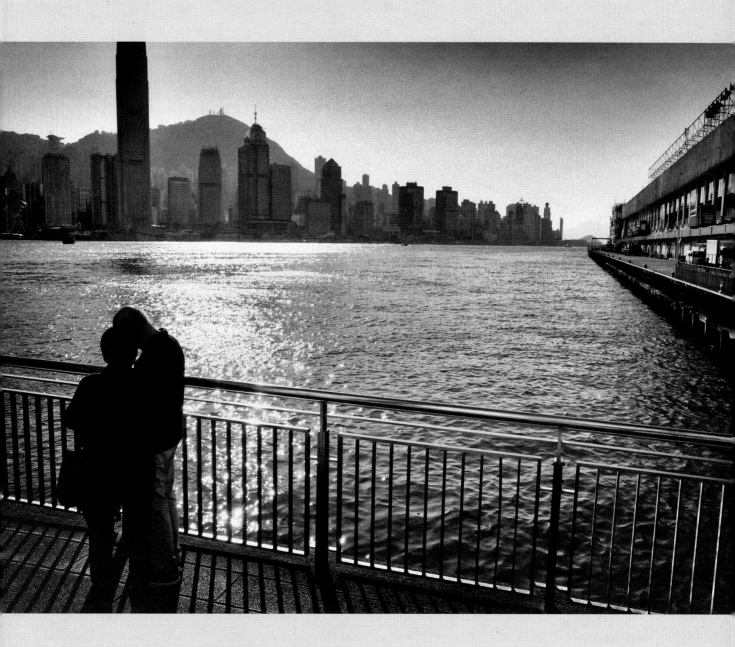

生命，生活。
（攝於香港・九龍 . 旺角）

Life goes on.
(Mongkok, Kowloon, Hong Kong)

117

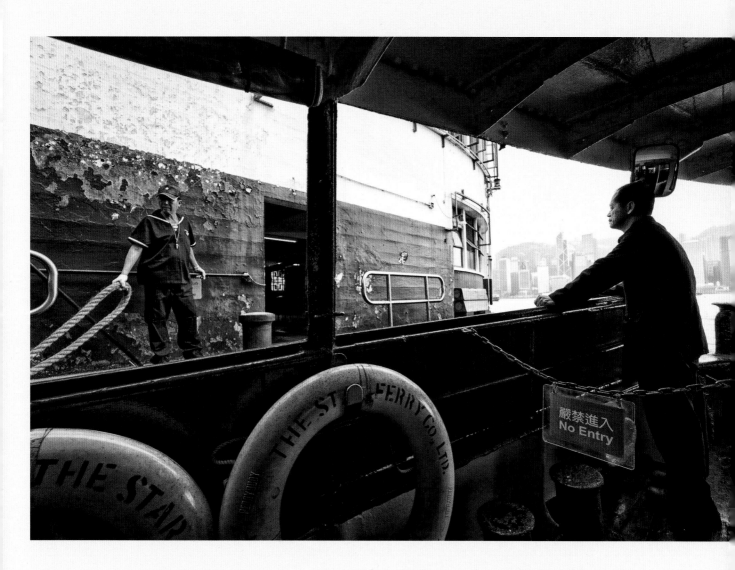

手足情深。
(攝於香港・九龍・尖沙咀・天星小輪碼頭)

Brotherhood. The purest friendship.
(Star Ferry Pier in Tsim Sha Tsui, Kowloon, Hong Kong)

王維《終南別業》：行到水窮處，坐看雲起時。
（攝於美國 · 波士頓）

Soul searching is a lifelong journey of discovery.
(Boston, USA)

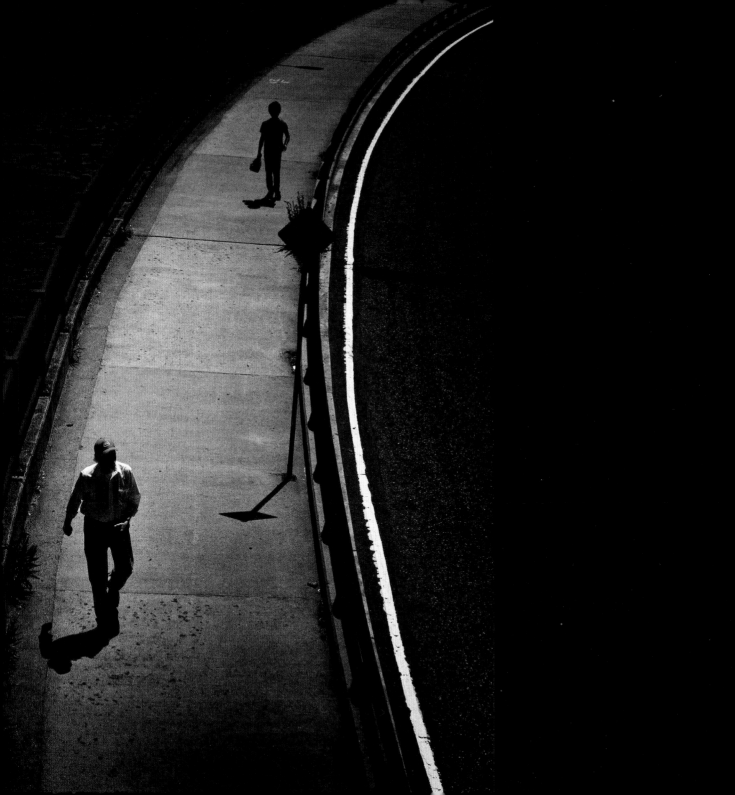

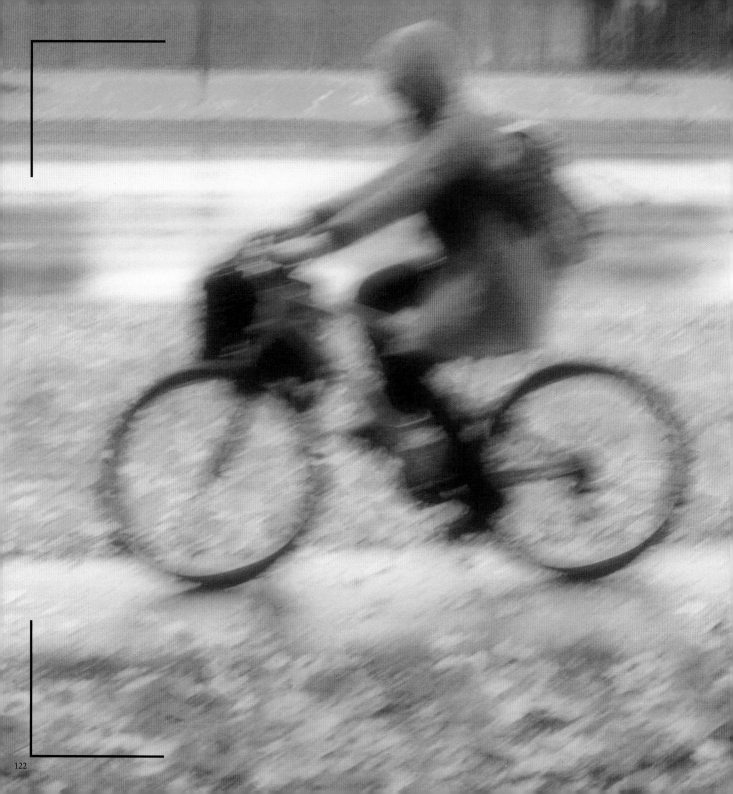

PART 8: **永恆的浪漫** | The Homecoming

永恆的浪漫，青山依舊夕陽紅。
（攝於香港・大澳）

The homecoming. My timeless romance.
(Tai O, Hong Kong)

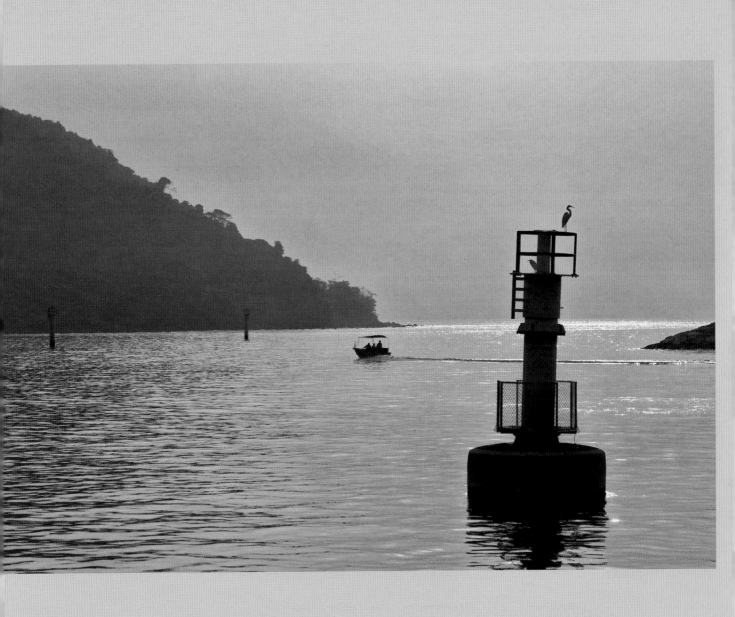

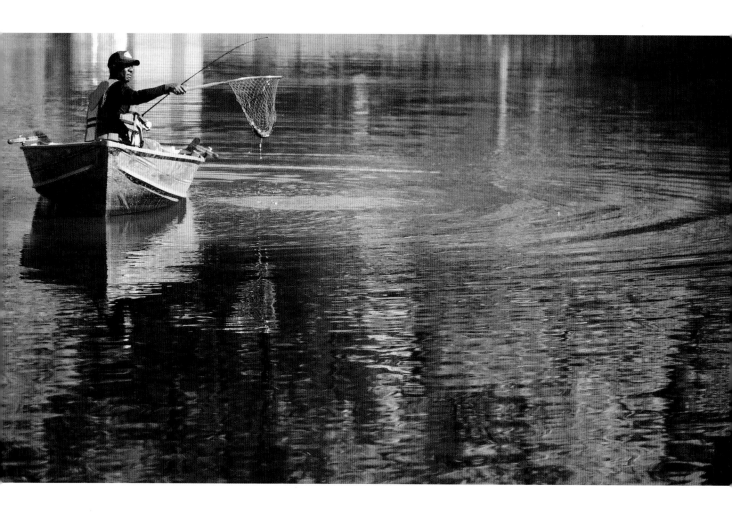

人生有幾多個十年？
（攝於加拿大・安省・心湖）

On golden pond.
(Heart Lake, Ontario, Canada)

她傳奇的一生。
（攝於香港・元朗・南生圍）

Watercolor memories. A lifetime of love.
(Nam Sang Wai, Yuen Long, New Territories, Hong Kong)

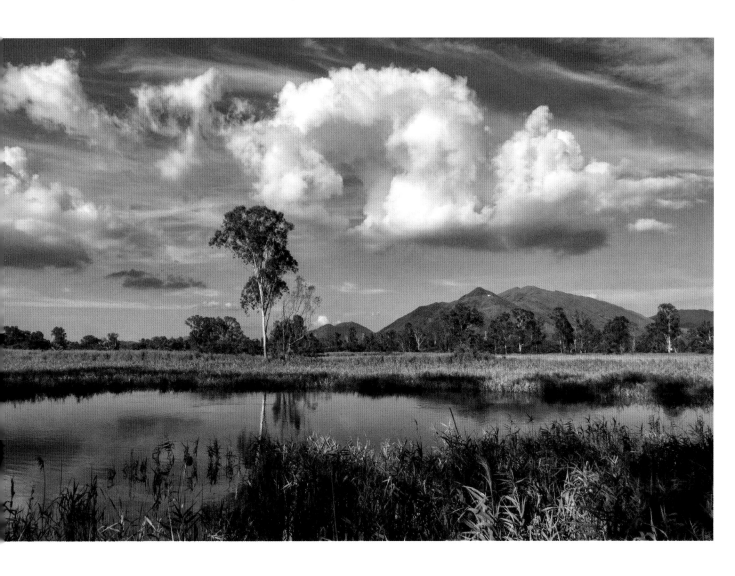

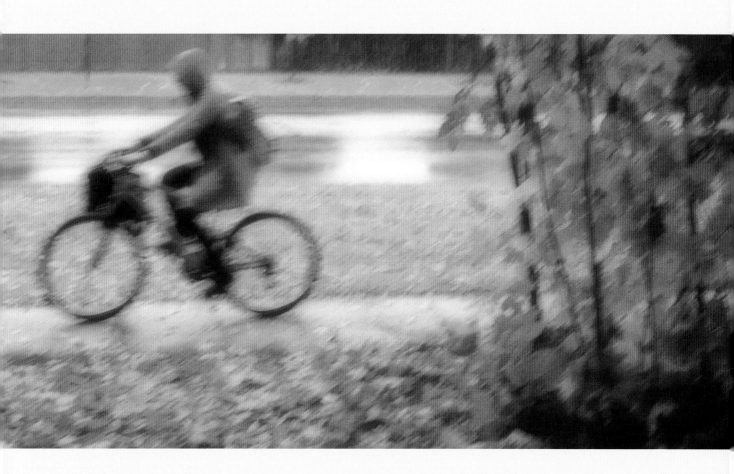

我喜歡妳。
（攝於加拿大・多倫多）

Love is you.
(Toronto, Canada)

有誰共鳴。
（攝於香港・大風坳）

My soul at peace in the silence.
(Quarry Gap, Hong Kong)

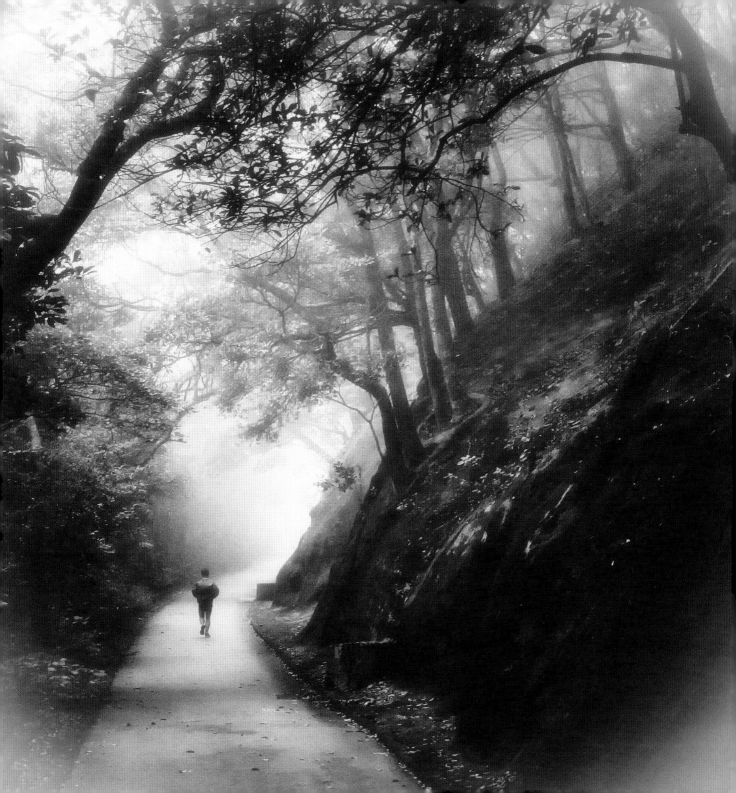

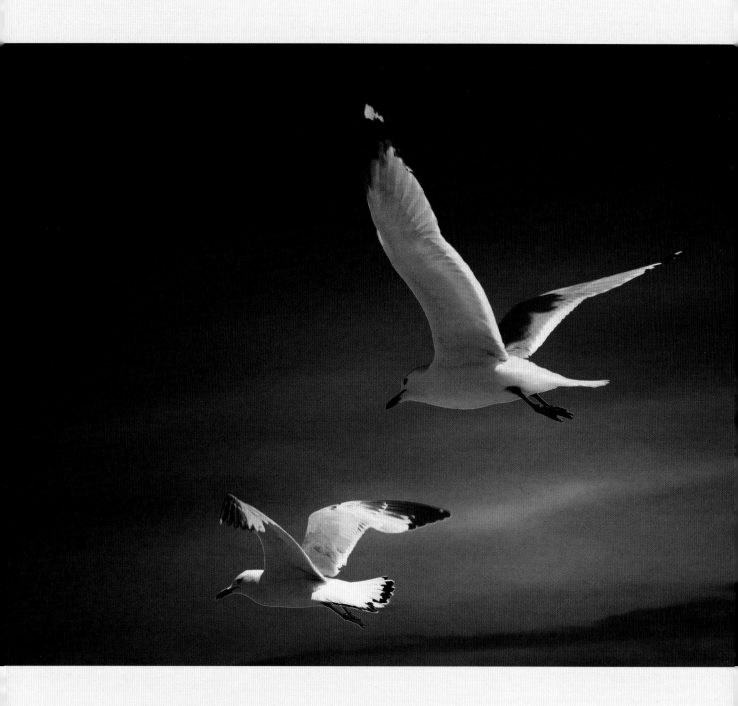

天地一沙鷗。

Enjoy the freedom and happiness to be your true self.

📷 結語

順流逆流・回到未來

順流・逆流。逝去歲月不會再回頭。
（攝於香港・九龍・尖沙咀・遠眺維港）

Either get bitter or get better. The choice belongs to us. Back to the future.
(Harbourview, Tsim Sha Tsui, Kowloon, Hong Kong)

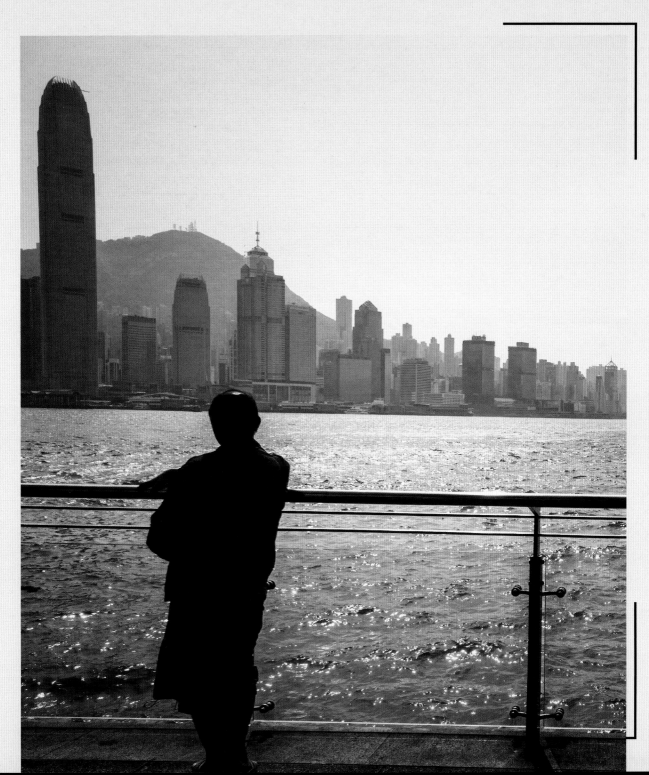

鳴謝

創作《追夢者的樂園》的心路歷程、感恩之情非語言能盡形容。

感激榮幸得到六位極富創意 VIP 成功人士的勵志支持，抒寫序文聯合推薦，令《追夢者的樂園》更能透徹凝聚追夢者（Dream Chasers）的心靈動力、勇氣、成功信念。感謝你：Heidi Lee, Bernard Chan, Dr. Winnie Tang, Dr. Martin Szeto, Doris Leung, Grace Choy。

《追夢者的樂園》能順利出版，感謝紅出版集團總經理 Patrick Lim 及編輯製作團隊的專業精準設計執行。

感恩予我無限支持的賢內助兼首席財務總監 Janet、女兒 Michelle、兒子 Michael、和我的家人。他們都是我這個開心追夢人的 Happy Fans。

誠摯感謝所有愛護及不斷支持我的好朋友。愛你們。

祝願大家享受追夢人生。深信每位 Dream Chaser 皆步上更美麗豐盛的人生旅程。

Dream Bigger. Be Vibrant, Be You!!

謝謝。

ABOUT THE AUTHOR

PETER K.C. HO was born in Hong Kong in 1957. At age 19, he emigrated to Canada with his parents. He graduated from the Ryerson University's School of Image Arts (major motion picture) in Toronto.

After 6 years work engagement as assistant film director, TV commercials cameraman, senior TV producer, TV program developer, TV show host in Hong Kong and Canada, he joined the financial consulting, investment advisory profession at age 30 and built his proven track record as director, first vice president, senior investment advisor, portfolio manager and chartered investment manager with prominent international financial institutions for 32 years.

Ho retired from the financial industry in 2020 and now focuses his time, energy and creativity on inspirational photography and writing. *TREASURE ISLAND: THE ADVENTURES OF A DREAMER* is the pilot edition of his inspirational photo journal book series, in the self-help, self- discovery & wellness, faith & spirituality book genre category.

As an international award-winning image arts creative in news, sports, personality, lifestyle and advertising music photography, Ho is an active explorer in the black+white environmental portrait photography genre. His photo credits include Delta Sky inflight magazine, The Globe And Mail, One Eyeland Book, Applied Arts magazine's Creative Calendar, Germany's Capital business magazine and other digital media channels. He is an Associate of The Royal Photographic Society, UK.

TREASURE ISLAND:
The Adventures of A Dreamer
追夢者的樂園

作者： 何廣暢

編輯： 劉彥星

設計： 4res

出版： 紅出版（青森文化）

地址：香港灣仔道133號卓凌中心11樓

出版計劃查詢電話：(852) 2540 7517

電郵：editor@red-publish.com

網址：http://www.red-publish.com

香港總經銷： 聯合新零售（香港）有限公司

台灣總經銷： 貿騰發賣股份有限公司

地址：新北市中和區立德街136號6樓

(886) 2-8227-5988

http://www.namode.com

出版日期： 2022年4月

圖書分類： 攝影 / 心靈勵志

ISBN： 978-988-8743-83-4

定價： 港幣120元正／新台幣480圓正